D0859212

IMAGES
of America

UKRAINIANS OF CHICAGOLAND

On the cover: **THE SURMA MALE CHOIR OF CHICAGO.** This is a 1960 photograph of the Surma Male Choir, a multidenominational group of Ukrainian men who came together for the sheer pleasure of singing Ukrainian songs. The director was Omelan Pleshkewycz. The choir was always in demand at various Ukrainian cultural functions in Chicagoland. (Author's collection.)

IMAGES
of America

UKRAINIANS OF CHICAGOLAND

Myron B. Kuropas, Ph.D.

ARCADIA
PUBLISHING

Copyright © 2006 by Myron B. Kuropas
ISBN 0-7385-40093

Published by Arcadia Publishing
Charleston SC, Chicago IL, Portsmouth NH, San Francisco CA

Printed in the United States of America

Library of Congress Catalog Card Number: 2006927303

For all general information contact Arcadia Publishing at:
Telephone 843-853-2070
Fax 843-853-0044
E-mail sales@arcadiapublishing.com
For customer service and orders:
Toll-Free 1-888-313-2665

Visit us on the Internet at www.arcadiapublishing.com

*This book is dedicated to my grandchildren,
Mariana, Kathryn, Kailee, Andrew, Natalie, and plus one
on the way, in the hope that they will nurture their rich
Ukrainian heritage wherever their lives take them.*

CONTENTS

ACKNOWLEDGMENTS

I first want to thank my beautiful life's companion, Alexandra "Lesia" Kuropas for her assistance, both moral and physical. She kept me on task, encouraged me when I became frustrated, and traveled with me while I was collecting photographs. My son Michael and wife Patty were patient and generous with their time in helping me with technical issues. Katya Mischenko was involved with this project from the very beginning, collecting photographs from the Ukrainian Orthodox community as well as from the archives of the Ukrainian National Museum in Chicago. Jaroslaw Hankewycz, director of the Ukrainian National Museum, was extremely helpful in providing access to one-of-a-kind photographs collected by the museum. Maria Klimchak, museum administrator, pointed me in the right direction once I was in the museum. My thanks go to Boris and Irene Antonovych, who shared many of the photographs that originally appeared in *Ekran,* a magazine once published by Boris's father, Adam Antonovych. Walter Tun of Selfreliance presented me with many photographs to consider for this publication. George Matwyshyn and his daughter Marta shared photographs George was collecting in preparation for the St. Nicholas Church centennial celebration. Dr. Daria Markus and Fr. Mykhailo Kuzma offered helpful suggestions for improvement of the text. Others who assisted in the collection of photographs and materials were Areta Akerstrom, Slawko Pihut, Oksana Dobrowolsky, and Margaret Matviuw of Immaculate Conception Catholic Church in Palatine; Oleh Kowerko of the Ukrainian Museum of Modern Art; Joe Bregin of Blessed Virgin Mary Catholic Church in Palos Hills; Fr. Taras Naumenko of SS. Peter and Paul Orthodox Church in Palos Hills; Roma Hadzewycz, editor of the *Ukrainian Weekly*; Dr. Vasily Truchly who sent photographs of choirs he and his father directed; Natalia Zavadovych for her photographs of the Medvid affair; Julian E. Kulas, Olya Kusyk, Christia Weresczak and Victoria Kawka for SUM photographs; Walter Sawkiw shared many historic photographs from St. Joseph parish as did Oksana Melnyk; Natalie Czuba for her assistance in locating photographs of St. Nicholas; Daria Jarosewycz and Lubomyra Kalin for the UNWLA photographs; Anatole Kolomayets, Oksana Teodorowycz, Lesia Kochman and Christine Taran for their individual photographs; Fr. Oleh Kryvokulsky, Maria Pylypczak, and Stephanie Babij of St. Josephat Church in Munster, Indiana; and John F. Kurey, Esq., for the photographs related to the Ukrainian Catholic Educational Foundation. I am especially grateful to Lialia Kuchma who shared photographs from *Generations*, a book she coauthored with Irene Antonovych. Finally, I want to thank Melissa Basilone, my editor, for her assistance. She is a true professional, a joy to know.

INTRODUCTION

Immigrants from what is today Ukraine have lived in the Chicagoland area since the late 1880s. Economic opportunity was their goal. While here, they discovered and developed their own unique national culture, an opportunity denied them in a homeland occupied by Austro-Hungary, Poland, and Russia. Ukrainian immigrants arrived in Chicago during four separate time periods: 1885–1914; 1923–1939; 1948 –1960; and 1991–the present.

Prior to World War I, most immigrants from Ukraine called themselves "Rusyns" (Ruthenians), the ethno-national identity they had in Austro-Hungary. It was in the United States that some 40 percent of the Rusyns came to call themselves Ukrainian.

The Austro-Hungarian and Russian empires collapsed during World War I, and on January 22, 1918, the people of Ukraine declared their independence. Freedom was short-lived, however. Following invasions by Czarist Russians, Soviet Russians, and Poland, Ukraine's government collapsed. The Ukrainian people were eventually divided among four nations: Czechoslovakia, Romania, Poland, and the Soviet Union.

The second mass immigration from Ukraine originated in the Ukrainian provinces of Poland and Romania. Many new immigrants were veterans of Ukraine's war of independence and were keenly aware of their ethno-national heritage. Their goal was to find a job, preserve their heritage, and to keep the hope of a resurrected Ukrainian nation-state alive.

Ukraine's third mass immigration began after World War II. As refugees fleeing Soviet rule, they came following passage of the Displaced Persons Act of 1948. Some immigrants had served in the Ukrainian Insurgent Army, which fought both the Nazis and the Soviets during the war. Others had suffered in Nazi labor and concentration camps.

Following World War II, all western Ukrainian territories were incorporated into the Ukrainian Soviet Socialist Republic (UkrSSR). With Moscow in absolute control, however, Ukraine was neither free nor sovereign. When the Soviet Union imploded in 1991, Ukraine's people declared their independence a second time. The political and economic uncertainty that followed the Soviet collapse, however, forced millions of people to leave Ukraine between 1991 and 2006. The fourth wave of Ukrainian immigrants to Chicagoland is estimated to be upward of 10,000.

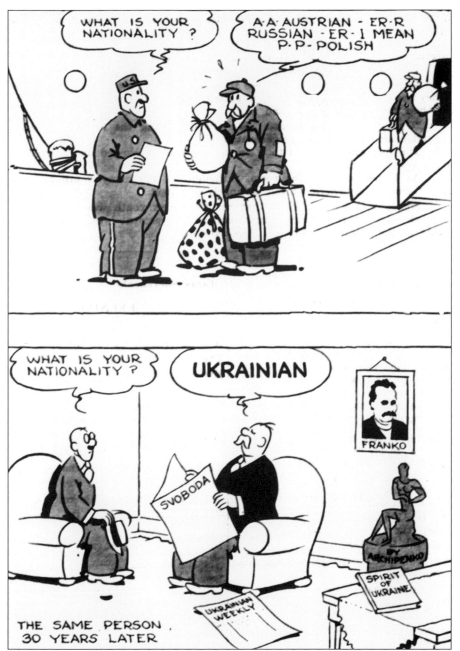

"WHO ARE WE?" Prior to World War I, western Ukraine was part of the Austro-Hungarian Empire while eastern Ukraine was under Czarist Russian rule. Ukraine's first immigrants began their journey from Ukrainian provinces in Austro-Hungary. This cartoon addresses the identity crisis faced by early Rusyn immigrants from Austro-Hungary at the beginning of the 20th century and the role played by Ukrainian societies in the Ukrainianization process, led at the time by the Ukrainian National Association (once called the Ruthenian National Union), a fraternal benefit society founded in 1894. Drawn by John Rosolowicz, the cartoon appeared in the *1936 Jubilee Book of the Ukrainian National Association in Commemoration of the Fortieth Anniversary of its Existence*, a monumental 752-page history of Ukrainians in the United States.

CHICAGO'S FIRST UKRAINIAN. The first ethno-nationally aware Ukrainian immigrant in Chicago was Volodymyr Simenovych, a physician who settled here in 1893. A graduate of John Hopkins University Medical School, he enjoyed a thriving medical practice in the city until his death in 1932. Prior to arriving in Chicago, Dr. Simenovych lived in Shenandoah, Pennsylvania, America's first Ukrainian community, where he edited *Ameryka*, the first Ukrainian-language newspaper in the United States, established a reading room where illiterates were taught to read, and managed a Ukrainian cooperative grocery store. A cultural and political activist in Chicago's burgeoning Ukrainian community for many years, Dr. Simenovych was one of the founders of St. Nicholas parish. He was also one of the organizers of the Brotherhood of St. Nicholas, a fraternal branch of the Ukrainian National Association (UNA). Later in life he headed *Prosvita*, a national enlightenment society established by the UNA, and edited *Ukraina*, a weekly newspaper published in Chicago during the 1930s.

One

GOD AND COUNTRY

Christianity became the official religion of Ukraine in 988 during the reign of Prince Volodymyr of Kyiv. Volodymyr's grandmother, Queen Olha, was already a Christian. Tradition says that the prince ordered a mass baptism of his people in the Dnieper River by Byzantine priests and bishops from Constantinople.

A major division within the Christian Church occurred in 1054. The Christian followers of the patriarch of Constantinople came to be called Orthodox while those who followed the Pope of Rome were called Roman Catholics.

During the 14th century, most of Ukraine fell under Polish rule. A Roman Catholic state, Poland endeavored to convert the Ukrainian Orthodox population to Catholicism. Ukrainians resisted, but with no political state of their own, the Greek Orthodox Church in decline, and Moscow claiming pre-eminence over the entire Orthodox world (as the Third and Final Rome), maintaining religio-cultural integrity became increasingly difficult. Believing that ecclesiastical recognition by Rome would strengthen their hand against Moscow and provide respite from the Poles, Ukrainian Orthodox prelates traveled to Rome to negotiate a union. They were warmly welcomed, and on December 23, 1595, Pope Clement VIII issued a papal bull recognizing the right of Ukrainian priests to marry as well as "all sacred rites and ceremonies which they use according to the institutions of the sacred Greek fathers." Ukrainian prelates, in turn, agreed to recognize the primacy of the pope. This, in effect, made the Ukrainian Catholic Church an Orthodox Church in union with Rome. Upon their return to Ukraine, however, the bishops discovered that certain powerful lay leaders were opposed to the union. Some bishops decided to disavow the agreement and remained Orthodox while other bishops held firm. From that day forward, most Ukrainian believers have identified themselves as either Orthodox or Catholic.

In addition to their spiritual reverence, Ukrainian Americans love the United States and have always been loyal citizens. Thousands of Ukrainians have proudly served in the U.S. armed forces in every major conflict since World War I. Fallen heroes are remembered in a special way every Memorial Day.

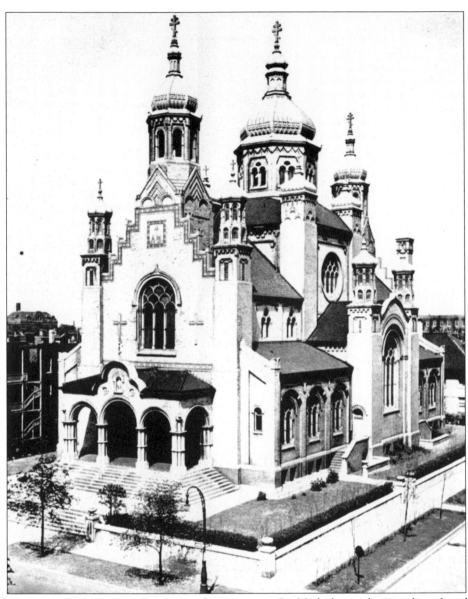

St. Nicholas Ukrainian Catholic Cathedral. St. Nicholas is the "mother church" of all Chicagoland Ukrainian churches. On December 31, 1905, some 51 Rusyns came together at 930 Robey (now Damen) Avenue to formally establish the St. Nicholas Ruthenian Catholic Parish. A 12-member board of directors was elected, with Fr. Viktor Kovalicki as chairman and pastor and Dr. Simenovych as secretary. An old wooden church on Superior Street and Bickerdicke Avenue was purchased in 1907. Later, in response to a call by Dr. Simenovych "to build a new Rus right here in Chicago," parishioners purchased some 20 lots on Rice Street between Oakley Boulevard and Leavitt Street. The cornerstone for a new church was blessed by Bishop Soter Ortynsky on November 27, 1913, and the present structure was completed within two years. St. Nicholas became a cathedral in 1961 when Msgr. Jaroslaw Gabro, who grew up in Ukrainian Village, was consecrated bishop of the newly created Ukrainian Catholic Eparchy of St. Nicholas. The current pastor is Fr. Bohdan Nalysnyk. He is assisted by Fr. Volodymyr Hudzan, Fr. James Bankston, and Deacon Mychajlo Horodysky.

FATHER NICHOLAS STRUTYNSKY.
Father Strutynsky became pastor
of St. Nicholas parish in 1907 and
quickly became a leader in the
Ukrainianization of Rusyns in
Chicago. A frequent contributor
to *Svoboda* (Liberty), a
Ukrainian-language newspaper
published by the UNA, he was one
of a new breed of patriot-priests from
Ukraine. It was Father Strutynsky
who convinced his parishioners to
build the magnificent St. Nicholas
Church on Rice Street and
Oakley Boulevard.

BASILIAN FATHERS OF CHICAGO. Management of St. Nicholas and other Ukrainian Catholic parishes in Chicago fell to the Basilian Fathers during the 1930s. From left to right in this 1941 photograph are (first row) Rev. Sylvester Zurawecky, pastor of St. Mary's Church; Very Reverend Ambrose Senyshyn, superior and pastor of St. Nicholas; and Rev. Innocent Rychkun, pastor or St. Michael's Church; (second row) Brother E. Stefura; Rev. Bessarion Andreychuk; Rev. Nestor Fecica; and Rev. Theodosius Greb.

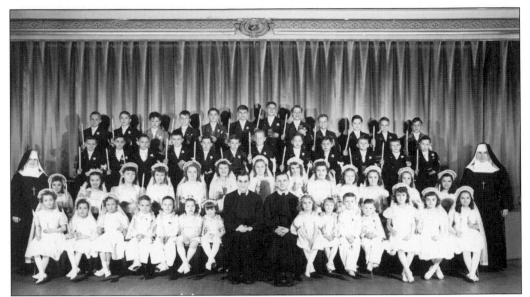

FIRST HOLY COMMUNION AT ST. NICHOLAS. This large class of children at St. Nicholas Church took their First Holy Communion on May 16, 1948. Fr. Bessarion Andreychuk sits center left.

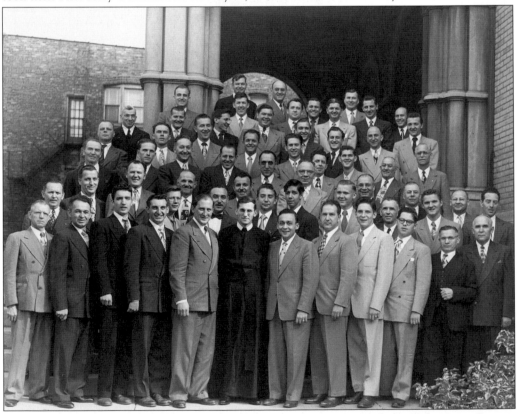

ST. NICHOLAS HOLY NAME SOCIETY. This photograph of the St. Nicholas Holy Name Society was taken on September 17, 1950. Father Andreychuk, the moderator, stands in the center in the first row.

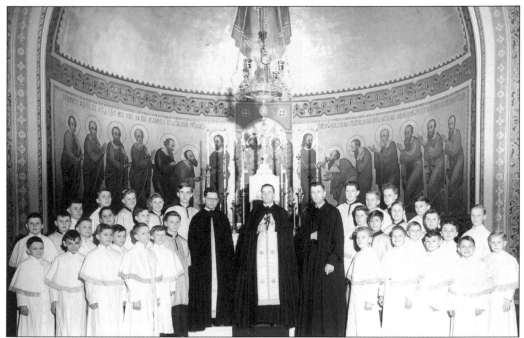

ST. NICHOLAS ALTAR BOYS SOCIETY. This picture of the St. Nicholas Altar Boys Society was taken in front of the altar in 1952. Fr. Wolodymyr Gavlich, the pastor, is in the center. The icons on the wall represent the Last Supper, with Jesus distributing his body and blood (consecrated bread and wine) to the 12 apostles.

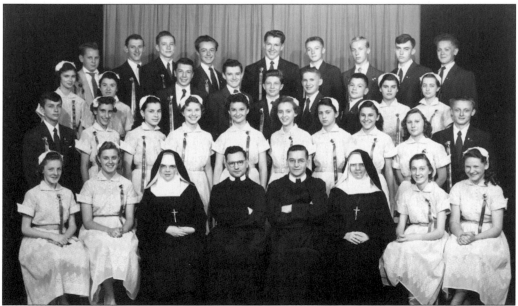

ST. NICHOLAS GRADUATION. The 1953 St. Nicholas Ukrainian Elementary School eighth-grade graduating class included, in the first row, left to right, Patricia Lonsky; Geraldine Kunio; Sr. Mary Angela, principal; Fr. Benedikt Siutyk, chaplain; Fr. Wolodymyr Gavlich, pastor; and Sister Mary, home-room teacher. Among the boys in the fourth row are Paul Nadzikewycz, a retired podiatrist today (fourth from left), and Slawomyr Pihut (ninth from left), a historian.

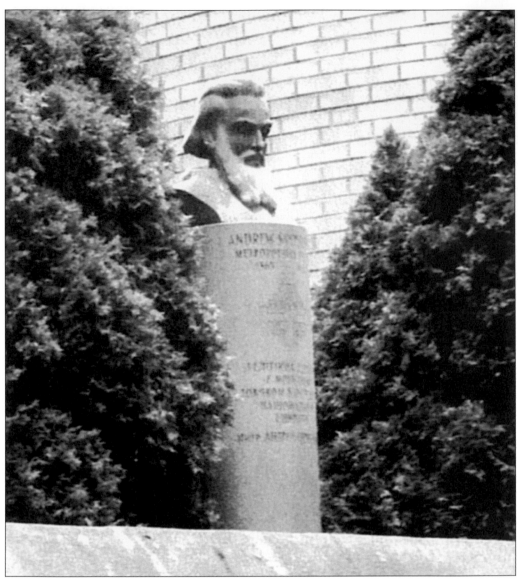

BUST OF METROPOLITAN ANDREY SHEPTYTSKY AT ST. NICHOLAS. This bust of Andrey Sheptytsky, Metropolitan of Lviv, Ukraine, sculpted by Msgr. Yaroslaw Swyschuk, sits on the grounds of St. Nicholas Cathedral. A saintly priest-patriot, Sheptytsky was horrified by Nazi behavior in Ukraine during their occupation, and protested to the Gestapo. When he discovered that some Ukrainians were complicit in these crimes, Sheptytsky issued a pastoral letter in November 1942, titled "Thou Shalt Not Kill." Working with his brother Klementii, leader of Lviv's Studite monks, the metropolitan commissioned nuns and priests to risk their lives saving Jews. If caught, the penalty for hiding Jews in Nazi-occupied Ukraine was death. False baptismal certificates were arranged for some 200 Jewish children who were smuggled into monasteries, orphanages, and convent schools in and around Lviv, including 15 who lived in the metropolitan's own residence. One of them was David Kahane, son of the Chief Rabbi of Lviv, a close friend of the metropolitan. According to the most recent count, 2,139 Ukrainians who rescued Jews have been recognized as "Righteous of the World" by the Yad Vashem Holocaust Museum in Israel.

St. Nicholas Chancery and Bishop's Residence. Located at 2245 West Rice Street, the bishop's chancery and residence was completed and blessed in 1967.

The corner of Rice Street and Oakley Boulevard. St. Nicholas Cathedral is located on the corner of Rice Street and Oakley Boulevard. The two streets have honorary names recognized by the City of Chicago: Bishop Jaroslaw Gabro Drive and Metropolitan Andrey Sheptytsky Boulevard.

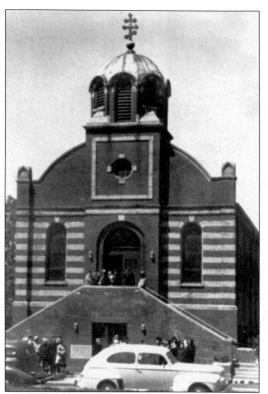

THE OLD SS. PETER AND PAUL CHURCH IN BURNSIDE. A parish was organized in the Burnside area by Fr. Volodymyr Petrovsky, and a second Ukrainian Catholic church was constructed at Ninety-second Street and Avalon Avenue in 1909. A serious rift occurred in 1928 when parishioners came to believe that Bishop Constantine Bohachevsky, Bishop Ortynsky's successor, was attempting to "Latinize" the Ukrainian Catholic Church nationwide. A majority of the parishioners voted to convert to Ukrainian Orthodoxy.

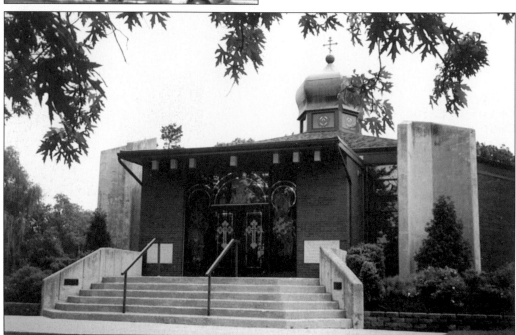

THE NEW SS. PETER AND PAUL ORTHODOX CHURCH IN PALOS HILLS. As more and more South Side Ukrainian Orthodox moved to the suburbs, the parishioners at SS. Peter and Paul decided to move their church as well. Land was purchased in Palos Hills, Illinois, in 1977 and a new church completed in 1979. The current pastor is Fr. Taras Naumenko.

BARBECUE AT SS. PETER AND PAUL. Family events such as picnics and barbecues at SS. Peter and Paul are often sponsored by the Ukrainian Orthodox League (UOL), a national organization with chapters at most Ukrainian Orthodox churches in the United States.

ST. MICHAEL'S UKRAINIAN CATHOLIC CHURCH IN WEST PULLMAN. Another Ukrainian Catholic parish was established in 1917 by former parishioners of SS. Peter and Paul. An old house served as the first church for the people of St. Michael's parish on Chicago's far South Side. A campaign to build a church was initiated by Fr. Isidore Kohut in 1957. The present structure, located at 12205 South Parnell, was completed in 1960.

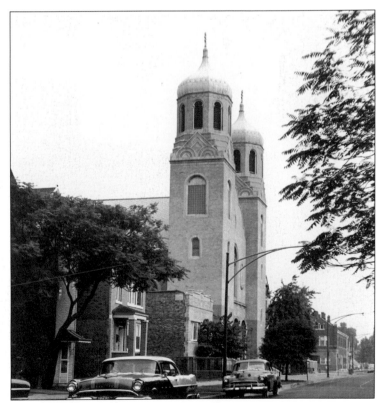

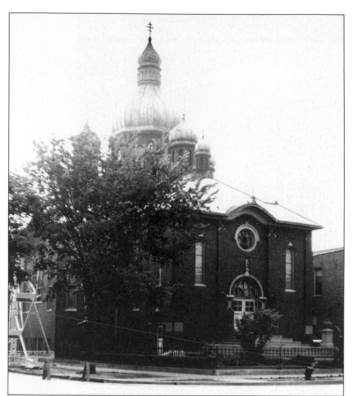

THE OLD NATIVITY OF THE BLESSED VIRGIN MARY (BVM) CATHOLIC CHURCH IN CHICAGO. Another Ukrainian Catholic community emerged in the working class Back-of-the-Yards area of Chicago in the early 1900s. By 1912, a church hall was constructed. A new church structure was completed at Fourty-ninth Street and Paulina Avenue in 1919. In 1956, an elementary school was opened adjoining the church. The school was closed in 1975 due to dwindling enrollment.

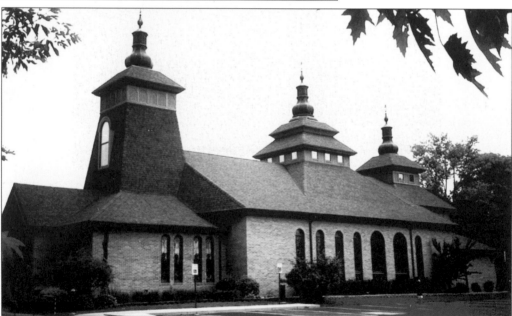

THE NEW CHURCH OF THE NATIVITY OF THE BLESSED VIRGIN MARY (BVM) CATHOLIC CHURCH IN PALOS HILLS. Ukrainian Catholics living in the Back-of-the-Yards area began their trek to the suburbs beginning in the early 1970s. Land was purchased in Palos Hills, Illinois, and in 1993, under the leadership of Fr. Abraham Miller, a new church was completed. The current pastor is Fr. Varcilio Basil Salkovski, a Ukrainian priest from Brazil. Fr. Demetrius Wysochansky assists.

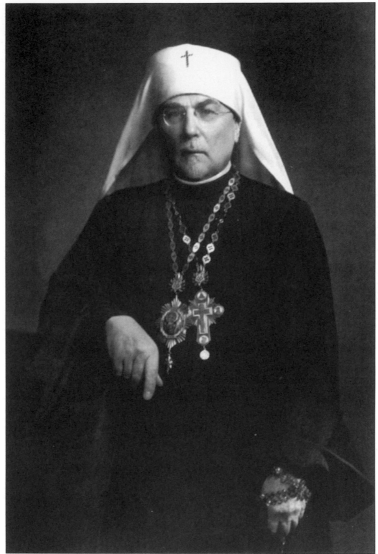

UKRAINIAN AUTOCEPHALOUS ORTHODOX BISHOP IVAN THEODOROVICH. The annexation of the Ukrainian Orthodox Church by the Muscovite Orthodox Patriarchate in the late 1600s led to the eradication of Ukrainian Orthodox autonomy. In 1921, during the days of Ukraine's first republic, the Ukrainian Autocephalous Orthodox Church was formally reestablished under metropolitans Vasyl Lypkivksy and Mykola Boretsky. All ties with the Moscow Patriarchate were severed. In Chicago, meanwhile, a group of St. Nicholas parishioners disenchanted with Father Strutynsky elected to convert to Orthodoxy. They purchased a church (Holy Trinity) at 1944 West Erie Street, and petitioned the Autocephalous Orthodox Church in Ukraine for recognition. Other U.S. parishes, unhappy with Ukrainian Catholic priests, also converted to Orthodoxy. In 1924, Kyvian Metropolitan Lypkivsky sent Bishop Ivan Theodorovich to Chicago, making Holy Trinity Orthodox Church the seat of the first Ukrainian Orthodox diocese in the United States. During the 1930s, Stalin forcibly annexed the Ukrainian Autocephalous Orthodox Church into the Russian Orthodox Patriarchate. Ukrainian bishops, priests, and faithful were either murdered or sent to the Gulag. Ukrainian Orthodoxy was restored in Ukraine following the collapse of the Soviet Union in 1991.

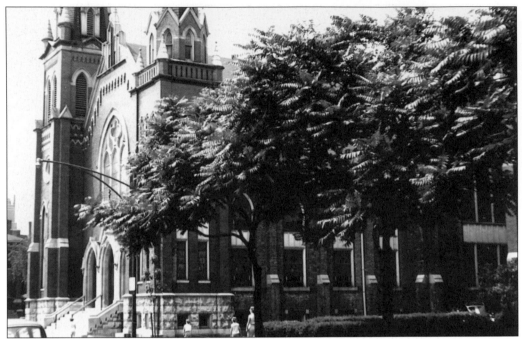

St. Volodymyr Ukrainian Autocephalous Orthodox Cathedral. Ukrainian Orthodox purchased a larger church at Oakley Boulevard and Cortez Street in 1946. It became a cathedral in 1969 with the appointment of Bishop Nowycky. He was succeeded by Bishop Constantine Bagan in 1972. The current pastor of St. Volodymyr is the Reverend Father Archmandrite Pankratij. The Ukrainian Orthodox Church USA (UOC-USA) elected to place itself under the authority of ecumenical patriarch Bartholomew in 1995.

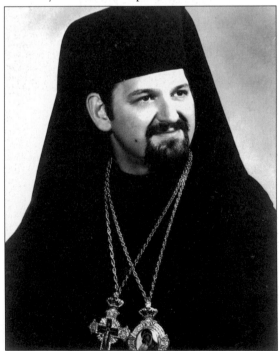

Ukrainian Autocephalous Orthodox Metropolitan Constantine. Ukrainian Orthodox bishop Constantine Bagan is shown here soon after his consecration in 1972. He was elevated to the rank of metropolitan for Ukrainian Orthodox in the United States in 1992. He remained in Chicago until 1994, when he was elevated to metropolitan for Ukrainian Orthodox living in Europe and Australia as well as the United States. He presently resides in Pittsburgh.

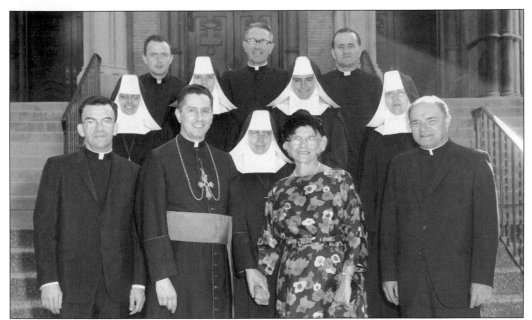

HER SON, THE BISHOP. Jaroslaw Gabro, Chicago's first Ukrainian Catholic bishop, was born and raised in Ukrainian Village. He is shown here in this 1961 photograph with his proud mother as well as priests and sisters of the new eparchy. Bishop Gabro headed the Chicago Eparchy of St. Nicholas from July 14, 1961, to his untimely death on March 28, 1980.

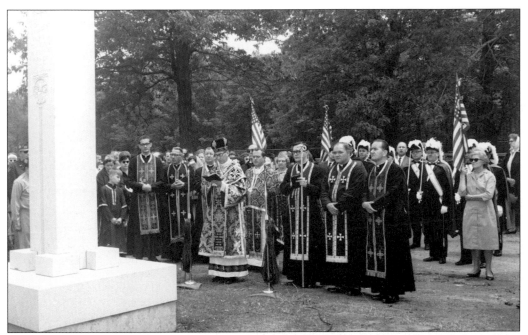

DEDICATING THE VETERANS MEMORIAL. Bishop Gabro blessed the newly erected Veterans Memorial obelisk at St. Nicholas Cemetery on Higgins Road. The tall priest to the left is Fr. Walter Klimchuk. To the bishop's left are Fr. Tom Glenn, Fr. Bill Bilinsky, Fr. Peter Leskiw, and Fr. Yaroslaw Swyschuk.

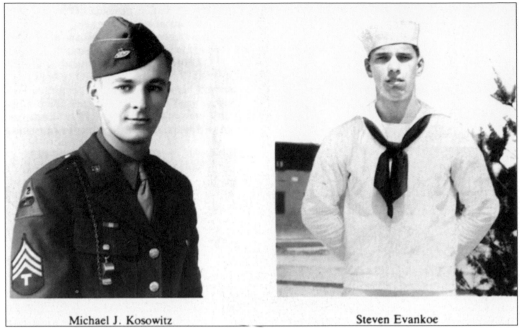

Michael J. Kosowitz Steven Evankoe

VETERANS OF FOREIGN WARS POST NO. 9420. The Kosowitz-Evankoe Post 9420 of the Veterans of Foreign Wars was formally established in 1947. The post honors two fallen Ukrainian comrades of World War II, Sgt. Michael Kosowitz, killed in Germany on November 6, 1944, and Fireman 1st Class Steven Evankoe, who perished aboard the battleship USS *Birmingham* in the Leyte Gulf on October 24, 1944.

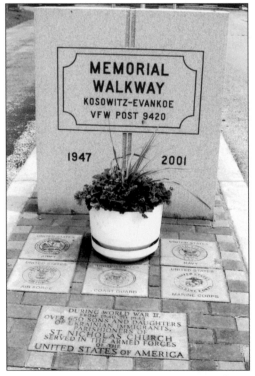

REFURBISHED PLAQUE. Recently refurbished, the memorial plaque at the Veterans Memorial at St. Nicholas Cemetery reads, "During World War II, from 1940 to 1945, over 650 sons and daughters of Ukrainian immigrants, parishioners of St. Nicholas Church, served in the armed forces of the United States of America."

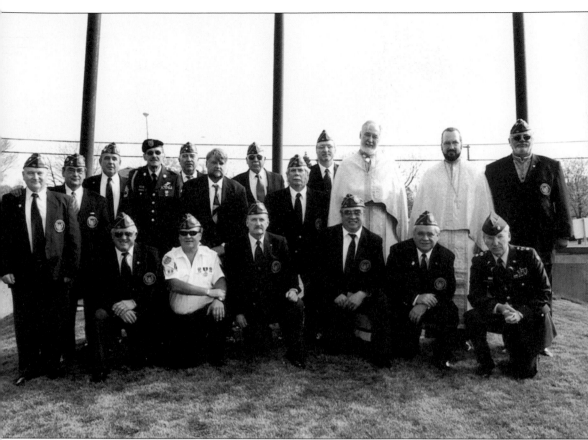

UKRAINIAN AMERICAN VETERANS, POSTS 32 AND 35. The Ukrainian American Veterans (UAV) was founded as a national organization in 1948. In cooperation with the Ukrainian American Military Association (UAMA), the UAV supports veteran affairs throughout the United States. This is a photograph of UAV Branch 32 at St. Joseph's Church in 2004. UAV Post 35 was established in Palatine in 2001. Post commander is army reserve Lt. Col. Roman Golash. Post chaplain is Fr. Bohdan Kalynyuk, pastor of St. Andrew Ukrainian Orthodox Church in Bloomingdale. UAV Post 35 is named after 1st Lt. Ivan Shandor, who spent 365 days with the 1st Infantry Division in Vietnam where he was awarded the Bronze Star for valor. Lieutenant Shandor was tragically killed in a traffic accident on his way to work in 1997. The UAMA was established in 1996 and became an affiliate of the UAV in 1997. The two priests standing to the right in the second row are Rev. Theodore Wroblicky of St. Nicholas parish, and Rev. Pavlo D. Hayda, pastor of St. Joseph parish.

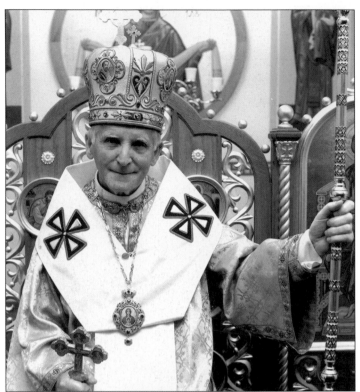

UKRAINIAN CATHOLIC BISHOP INNOCENT HILARION LOTOCKY. Bishop Innocent Lotocky, shown here in this 1999 photograph, was born in Ukraine. Ordained a Basilian priest in 1940, he succeeded Bishop Gabro as bishop of the Chicago Ukrainian Catholic eparchy on December 22, 1980. His soft and sensitive administration helped heal some of the animosities that had emerged earlier between parishioners at St. Nicholas and SS. Vololdymyr and Olha. He retired in 1993 at age 75.

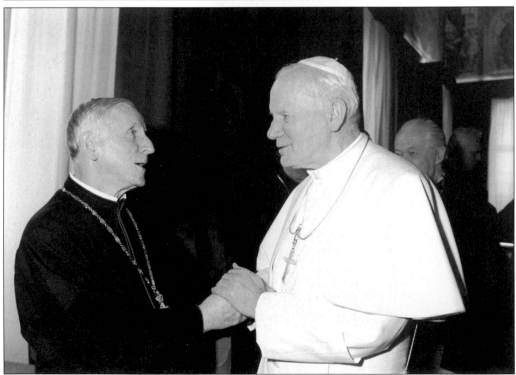

BROTHERS IN CHRIST. Bishop Innocent (left) meets with Pope John Paul II in 1988.

Archbishop Vsevolod of Scopelos. Archbishop Vsevolod received his monastic tonsure in 1985 and was ordained to the priesthood by Metropolitan Andrej (Kuschak) under the Ecumenical patriarch of Constantinople. He was elevated to the episcopacy in 1987 and served as primate of the Ukrainian Orthodox Church of America. He was elevated to the rank of archbishop by the Holy Synod of Constantinople in 2000. He resides in Chicago.

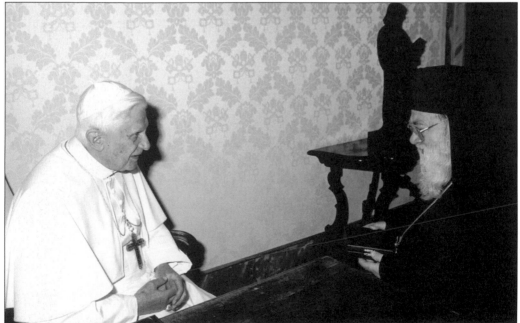

Archbishop Vsevolod and Pope Benedict XVI. Pope Benedict XVI (left) held a private audience with Archbishop Vsevolod on April 18, 2006. Since his Episcopal consecration, Archbishop Vsevolod has been a representative of the ecumenical patriarch in the ongoing dialogue between the Orthodox and Catholic Churches.

FR. JOSEPH SHARY. As Chicago's American-born generation migrated from the center of the city, it was apparent that another Ukrainian Catholic parish was needed. In 1956, Metropolitan Constantine Bohachevsky sent the indefatigable Fr. Joseph Shary, a New Jersey native, to Chicago to organize a new parish of Ukrainian Catholics on Chicago's northwest side. A temporary structure, constructed on Cumberland Road north of Lawrence Avenue, was used as the first St. Joseph church.

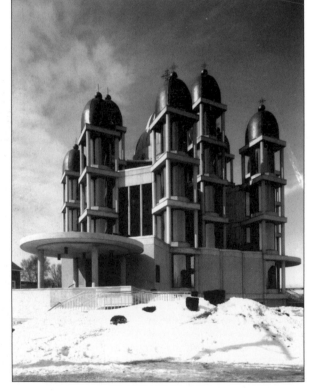

THE NEW ST. JOSEPH UKRAINIAN CATHOLIC CHURCH. A new St. Joseph Ukrainian Catholic Church was completed next to the old church in 1977 under Father Shary's direction. The church combines traditional and current trends in Ukrainian church architecture. There are 13 domes, the center one for Jesus, the other 12 for the apostles. The current pastor is Fr. Pavlo Hayda. He is assisted by Fr. Tom Glenn and a recently ordained priest, Fr. Stefan Kostiuk. The parish celebrated its 50th anniversary in 2006.

ST. JOSEPH ALTAR AND ROSARY SOCIETY. The St. Joseph Altar and Rosary Society has played an important role in parish affairs from the beginning of its existence. This photograph from the 1960s includes the pastor, Fr. Joseph Shary, fifth from left, and assistant pastor, Rev. Elias Denissoff, to his left.

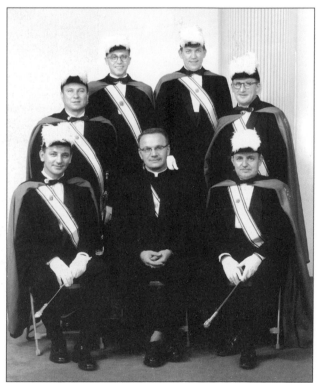

ST. JOSEPH CATHOLIC KNIGHTS OF COLUMBUS. Another significant church organization at St. Joseph is the Knights of Columbus, a Catholic fraternal insurance association. This 1960s picture of the Bishop Gabro Council of the Knights of Columbus at St. Joseph includes, left to right, (first row) Walter Sawkiw, Fr. Joseph Shary, and Ted Duzansky; (second row) Rudy Presslak, Paul Marinoff, George Kuzma, and John Gawaluch.

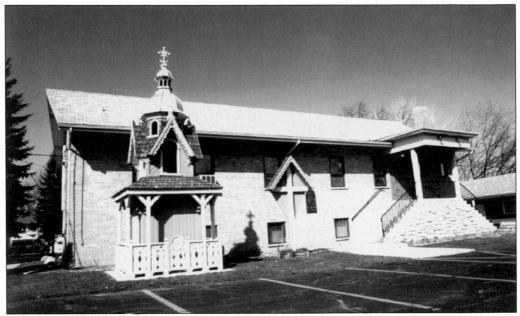

IMMACULATE CONCEPTION UKRAINIAN CATHOLIC CHURCH IN PALATINE. As Ukrainians moved out of Chicago to the northwest suburbs, the city of Palatine emerged as a new center of Ukrainian life. Upon the initiative of Fr. Joseph Shary, a church was erected in 1964 on Benton Street near Illinois Avenue. The current pastor is Very Rev. Archpriest Mykhailo Kuzma. He is assisted by a recently ordained priest, former deacon Fr. Andrew Plishka.

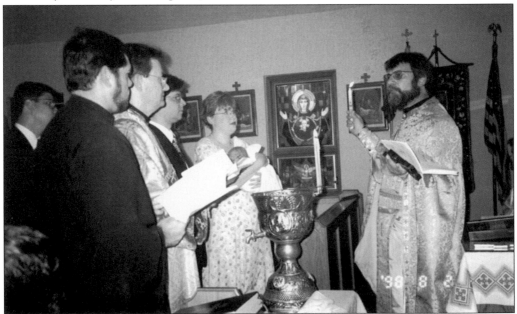

BAPTISM AT IMMACULATE CONCEPTION. In this 1998 photograph, Pastor Mykhailo Kuzma is baptizing Andrew Kuropas (according to the Byzantine Rites of Initiation). From left to right are Michael Plishka, cantor, Deacon Andrew Plishka, godfather Andrew Dijak, and godmother Patty Kuropas. In the Byzantine Christian tradition, the Mysteries of Initiation include baptism, *chrismation* (confirmation), and the reception of Holy Communion.

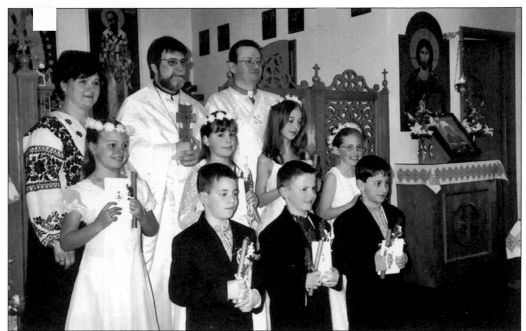

FIRST SOLEMN HOLY COMMUNION AT IMMACULATE CONCEPTION. Standing behind communicants, from left to right, are Oksana Kuzma, the pastor's wife and religion teacher who prepared the children; Rev. Archpriest Mykhailo Kuzma, pastor; and Deacon Andrew Plishka. Communicants include three boys, (left to right) Paul Gada, Nazary Dmytriuk, and Paul Wereminski, and four girls, Madeline Shewchuk, Olivia Gada, Victoria Kordyban, and Kathryn Kuropas.

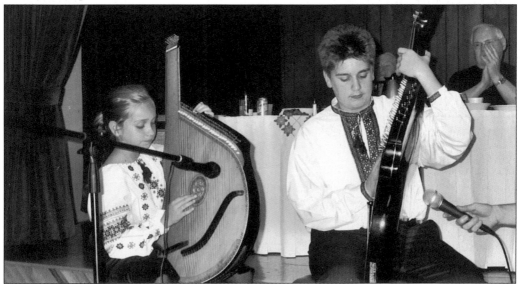

BANDURISTS AT IMMACULATE CONCEPTION. Laryssa and Alexander Magera are two young people at Immaculate Conception Church in Palatine learning to play the bandura, the Ukrainian national instrument and a symbol of Ukrainian nationalism. With 32 to 55 strings, the bandura is similar to the lute. Stalin once invited hundreds of blind bandura players to Moscow for a "celebration" and then had them shot. Bandura playing was outlawed in the Soviet Union.

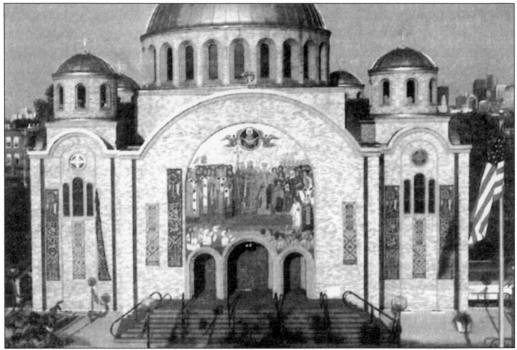

SS. Volodymyr and Olha Ukrainian Catholic Church. Believing that Bishop Gabro's decision to replace the Julian religious calendar with the Gregorian calendar was an attempt to "Latinize" their religio-cultural tradition, a number of parishioners left St. Nicholas Cathedral and built a new church in 1974 on the corner of Superior Street and Oakley Boulevard. The current pastor is Rt. Rev. Archpriest Mitred Ivan Krotec. He is assisted by Rev. Yaroslav Mendyuk.

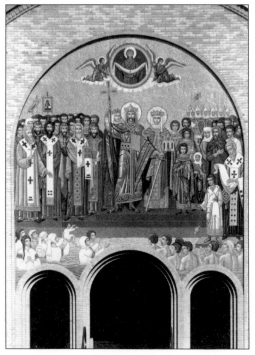

Entrance to SS. Volodymyr and Olha Ukrainian Catholic Church. A mosaic over the entrance to SS. Volodymyr and Olha Church depicts the baptism of Ukraine by Byzantine Christian bishops and priests from Constantinople in 988. In the center is St. Volodymyr, Ukraine's Christian ruler who, according to tradition, ordered his people into the Dnieper River to be baptized. His grandmother, St. Olha, also a Christian, is by his side.

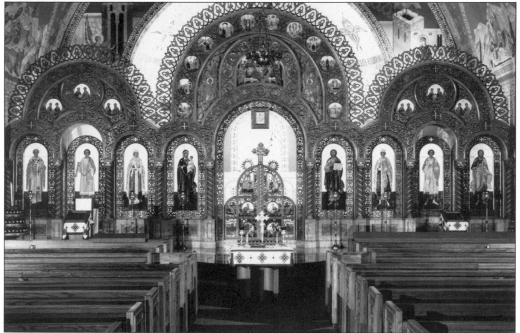

THE ICONOSTAS AT SS. VOLODYMYR AND OLHA UKRAINIAN CATHOLIC CHURCH. The iconostas, a distinctive feature in all Byzantine churches, Catholic and Orthodox alike, is situated between the sanctuary and the nave. The icon screen or wall with three doors bears images of Christ, the Mother of God, and the saints. The iconostas expresses the unity of God and man through Jesus Christ, who is both God and man.

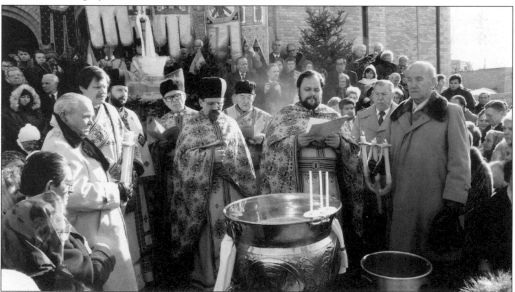

THEOPHANY (EPIPHANY) AT SS. VOLODYMYR AND OLHA. One of the great feasts of the Eastern Church (celebrated in January) is *Theophany* (Epiphany) commemorating the baptism of Jesus Christ in the Jordan River by St. John the Baptist. Priests bless and incense the water, symbolizing the descent of the Holy Spirit. Three candles, symbolizing the Holy Trinity made manifest during Christ's baptism, are also immersed in the water.

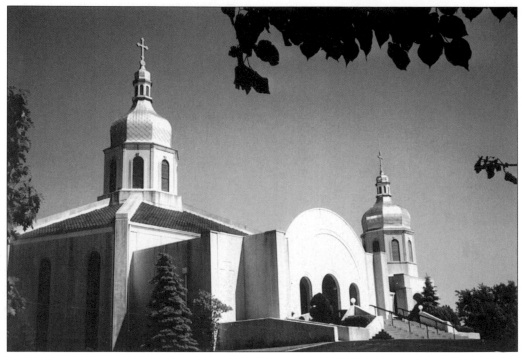

ST. ANDREW UKRAINIAN ORTHODOX CHURCH IN BLOOMINGDALE. This magnificent Byzantine-style Ukrainian Orthodox Church was completed in 1987. It stands at 300 East Army Trail Road in Bloomingdale, Illinois. The current pastor is Rev. Bohdan Kalynyuk.

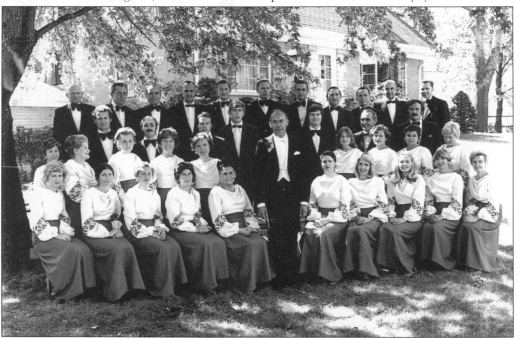

ST. ANDREW ORTHODOX CHURCH CHOIR. This photograph of the St. Andrew Orthodox Church choir was taken in 1980. The director was Vasyl Truchly, a medical doctor, who followed Ivan Truchly, his father, as director of the choir.

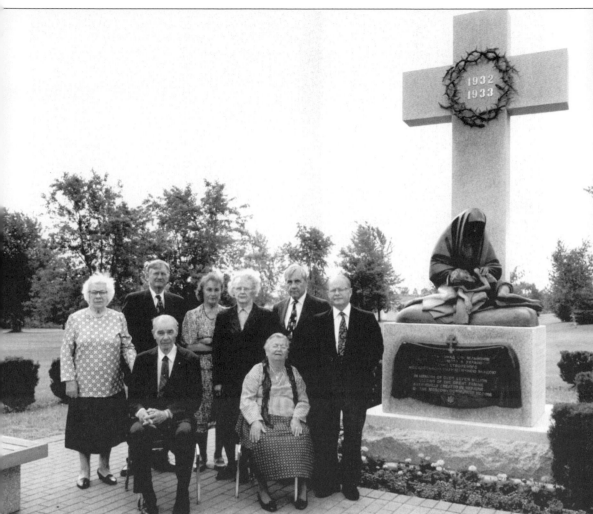

SURVIVORS OF THE UKRAINE FAMINE-GENOCIDE (HOLODOMOR) OF 1932–1933. Survivors of the Ukraine Famine-Genocide of 1932–1933 (*Holodomor* in Ukrainian) gathered by the memorial on the grounds of St. Andrew Orthodox Church in 1997. From left to right are (first row) Kasian Lischyna and Oksana Maruch; (second row) Fedokia Leschyna, Ivan Derkacz, Lidia Kurylak, Halyna Anna Terkun, Taras Kochno, and Ivan Jarescho. The famine-genocide in Ukraine was engineered in 1932–1933 by Joseph Stalin, brutal dictator of the totalitarian Soviet state, to crush Ukrainian resistance to collectivization and Moscow's tyrannical rule of Ukraine. In need of hard currency to build up the Soviet war machine during the 1930s, Stalin ordered all grain removed from Ukraine and sold on the Western market. Some 6 to 10 million people died of starvation. Neither the Soviet Union then, nor Russia today, has ever admitted responsibility for this genocide. *New York Times* foreign correspondent Walter Duranty visited Ukraine and observed the devastation, but, at the insistence of his Soviet handlers, wrote that "any talk of famine in Ukraine today is an exaggeration or malignant propaganda." Duranty was awarded the Pulitzer Prize in 1932.

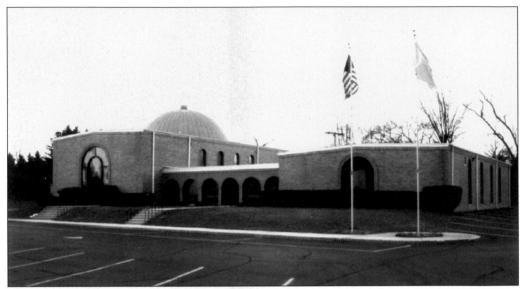

ST. JOSAPHAT UKRAINIAN CATHOLIC CHURCH IN MUNSTER, INDIANA. Originally organized as a mission church by Fr. Joseph Shary in 1958, the first St. Josaphat Ukrainian Catholic church was located in Hammond, Indiana. The congregation grew, and a new church was completed at 8624 White Oak Avenue in Munster, Indiana, in 1968. The current pastor is the Reverend Oleh Kryvokulsky, who was born and raised in Ukraine.

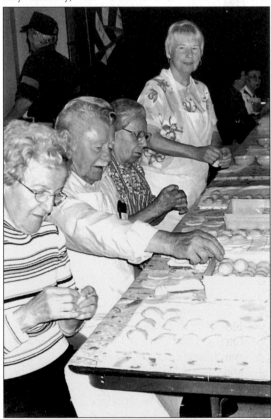

THE "PYROHY PEOPLE." Making *pyrohy* (dumplings) and selling them every Saturday is a great moneymaker for St. Josaphat Parish. Men and women, mostly senior citizens, participate. Other parishes in Chicagoland, especially St. Andrew in Bloomingdale, have a similar practice.

ST. SOPHIA UKRAINIAN ORTHODOX CATHEDRAL. The collapse of the Soviet Union led to the creation of the Ukrainian Orthodox Church, Kyiv Patriarchate (UOC-KP), under the leadership of Patriarch Filaret (Denysenko). St. Sophia Cathedral at 6655 West Higgins Road in Chicago is under the jurisdiction of the UOC-KP. The pastor is Fr. Myhaylo Pasieka.

HOLY PROTECTION UKRAINIAN ORTHODOX CHURCH. This church, which stands at the corner of Washtenaw Avenue and Iowa Street in Chicago, is also member of the UOC-KP, under the patronage of Patriarch Filaret in Kyiv. The pastor is Rev. Archimandrite Pityrym.

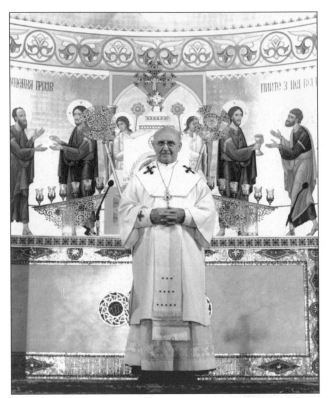

UKRAINIAN CATHOLIC BISHOP MICHAEL WIWCHAR. Born in Canada, Bishop Michael Wiwchar, a Ukrainian Redemptorist priest, succeeded Innocent Lotocky as bishop of the Chicago Ukrainian Catholic Eparchy on July 2, 1993. A dynamic administrator, he organized laity conferences in cities throughout his eparchy. He was appointed bishop of the Ukrainian Catholic Eparchy of Saskatoon, Saskatchewan, in 2000 while serving as apostolic administrator of the Chicago eparchy until March 2003.

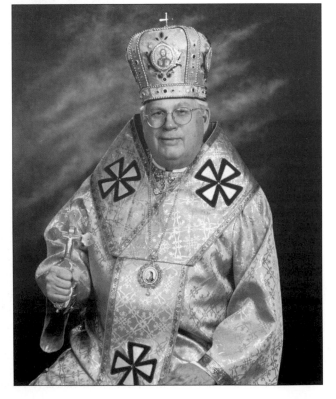

UKRAINIAN CATHOLIC BISHOP RICHARD STEPHEN SEMINACK. Born in Philadelphia, Richard Stephen Seminack was ordained a priest on May 25, 1967. After serving in both the Philadelphia Ukrainian Archeparchy and the Parma Eparchy, he was ordained bishop of the Chicago Eparchy of St. Nicholas on March 25, 2003. The St. Nicholas Eparchy encompasses territory that extends from Michigan to Hawaii and includes 42 parishes, missions, and monasteries in 14 states.

THE NEW UKRAINIAN BAPTIST CHURCH. With the arrival of Ukrainian Protestants, especially Baptists, after World War II, a parish was organized under the leadership of Rev. Olexa Harbuziuk. A church was purchased at 1042 West Damen Avenue in 1952. A new church was purchased in 1985 at 6751 Riverside Drive in Berwyn, Illinois. The current pastor is the Reverend Aleksander Kalinin, who was born in Ukraine and arrived in Chicago in 1991.

THE REVEREND OLEXA HARBUZIUK. Born in Ukraine, the Reverend Olexa Harbuziuk was the single most significant person in the Ukrainian Protestant movement in the United States for many years. He served as pastor of the Ukrainian Baptist church in Chicago and later in Berwyn for 16 years. During his lifetime he spoke at church conferences in Australia, Africa, South America, Canada, and the United States. He had seven children and 10 grandchildren.

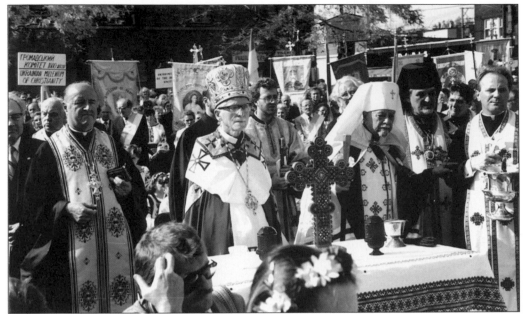

ECUMENICAL COMMEMORATION OF THE MILLENNIUM OF CHRISTIANITY IN UKRAINE. This ecumenical religious gathering to commemorate the millennium of Christianity in Ukraine took place in 1988 at the corner of Oakley Boulevard and Chicago Avenue. From left to right are Fr. Markian Butrynsky and Bishop Innocent Lotocky of the Catholic Church, Metropolitan Mstyslav Skrypnyk, Bishop Constantine, and Fr. Stefan Zenchuch of the Orthodox Church.

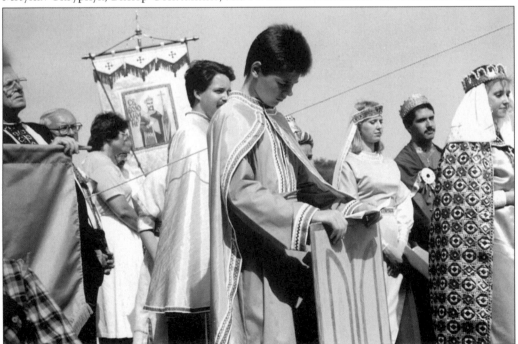

ECUMENICAL PROCESSION. This 1988 ecumenical religious procession to Lake Michigan featured "Prince Volodymyr," "Queen Olha," a "royal entourage," and Chicago's religious and lay leaders. A Divine Liturgy was later celebrated on the lakefront.

Two

Fraternal Institutions

Closely related to the growth and development of Ukrainian Catholic and Orthodox churches during the early years was the establishment of fraternal benefit societies. The leading such society in Chicago for many years was the UNA, founded in 1894 in Shamokin, Pennsylvania. Once called the Ruthenian National Union, the organization changed its name to the Ukrainian National Association in 1914. The UNA had 12 branches in Chicago by 1936. Currently there are 14 UNA branches in the Chicagoland area. The first UNA branch, the Brotherhood of St. Nicholas (branch No. 106) was founded by Dr. Volodymyr Simenovych and Fr. Nicholas Strutynsky in 1906. The UNA provided low-cost life insurance for its members and served as an enlightenment society as well. Currently the UNA national headquarters publishes two weekly newspapers, the Ukrainian-language *Svoboda*, founded in 1893, and the English-language *Ukrainian Weekly*, founded in 1933, as well as annual almanacs listing holy days and containing articles of current interest. The UNA held its quadrennial national convention in Chicago in 2002.

A second fraternal benefit society active among Ukrainians in Chicagoland is the Ukrainian Fraternal Association (UFA), founded as the Ukrainian Workingmans Association in 1911. The UFA publishes *Narodna Volya*, a weekly published in Ukrainian and English, and *Forum*, an English-language quarterly. In 2006, there were eight UFA branches in the Chicagoland area.

The Providence Association of Ukrainian Catholics was established in New York City in 1912. The first Chicago branch (No. 55) of Providence was founded at St. Nicholas parish on May 16, 1915. In 2000, another Ukrainian fraternal organization, the Ukrainian National Aid Association (*Narodna Pomich*), headquartered in Chicago, merged into the Providence Association. In 2006, there were seven Providence branches in the Chicagoland area. The Providence Association publishes *America*, a weekly newspaper in Ukrainian and English, and has branches in most Ukrainian-American communities.

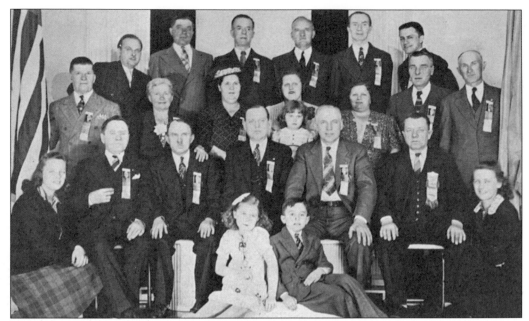

Brotherhood of St. George, UNA Branch 379. The Brotherhood of St. George, UNA Branch 379, was established in 1914. Its first officers were Theodore Kuchar, president, and Michael Klym, secretary. The membership then consisted of 27 members. In 1941, Basil Pylypiw was president, Andrew Bodnarchuk was secretary, and Max Fedinsky was treasurer. Membership total was 122.

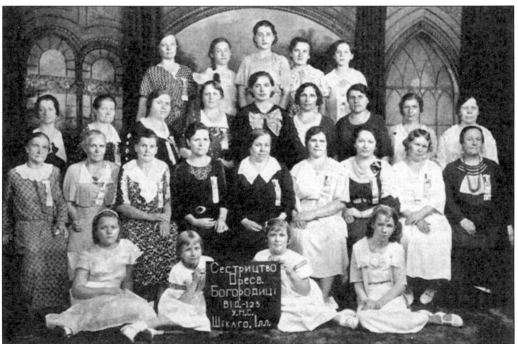

Sisterhood of the Blessed Mother, UNA Branch 125. This 1934 group photograph of UNA Branch 125, the Sisterhood of the Blessed Mother, demonstrates that various organizations, religious and secular, could establish their own unique and independent UNA branch.

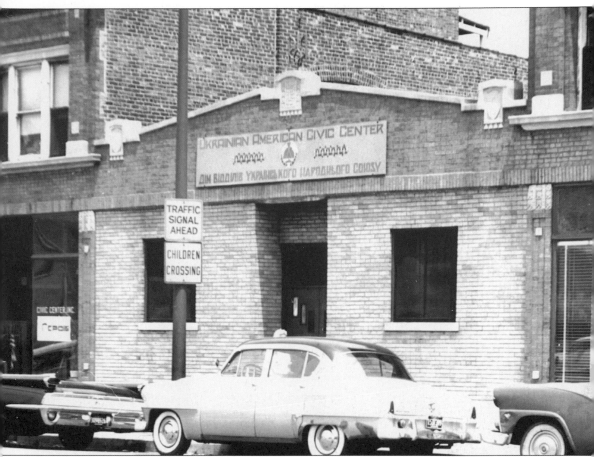

THE UKRAINIAN AMERICAN CIVIC CENTER. This building at 841 North Western Avenue was once the headquarters of the Ukrainian National Association in Chicago. It was here that hundreds of third-wave immigrant families were housed temporarily during the early 1950s. They slept on makeshift cots provided by the UNA and the United Ukrainian American Relief Committee (UUARC). Fearing the return of brutal Soviet control of Ukraine, Ukrainian immigrants left their homes and fled west ahead of the retreating German army in 1943. In constant fear of air attacks, they walked and occasionally rode on boxcars or wagons. When the war ended, they found themselves in Germany and Austria as displaced persons. The Displaced Persons Act, signed into law by Pres. Harry S. Truman in 1948, permitted them to come to the United States. Their stay on Western Avenue was short. Chicago's economy was booming and, with the assistance of UNA leaders such as Stephen Kuropas, Taras Shpikula, and others, third-wave immigrants were able to find jobs and living quarters within a few months after their arrival.

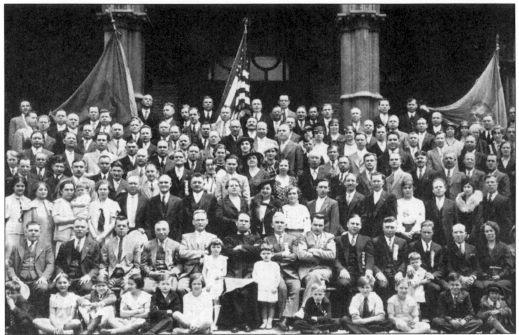

BROTHERHOOD OF ST. STEPHEN, UNA BRANCH 221. This group photograph of UNA branch 221, the Brotherhood of St. Stephen, was taken on the steps of St. Nicholas Church in 1935.

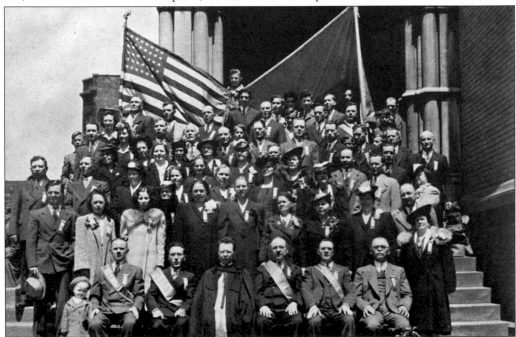

BROTHERHOOD OF MARKIAN SHASHKEWYCH, PROVIDENCE BRANCH 55. The Brotherhood of Markian Shashkewych, Providence Association Branch 55, was established at St. Nicholas Church in 1915 by Fr. Nicholas Strutynsky. Members came together for this photograph in 1941. The branch was named after Markian Shashkewych, a Catholic priest credited with being the first person in western Ukraine to write in the Ukrainian vernacular.

UNA Bowling Tournament Organizers in 1964. Bowling tournaments were just one of the many fraternal activities organized by the UNA during the 1960s. Seated in the second row, second from left, in this 1964 photograph of organizers of the UNA national bowling tournament is longtime national UNA advisor and UNA Branch 22 secretary Helen Olek.

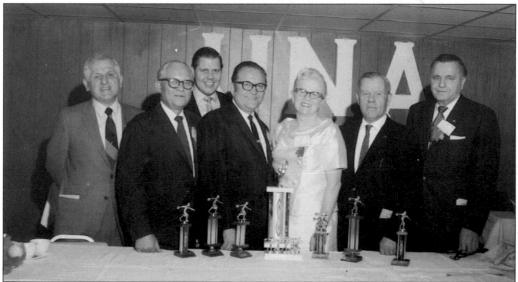

UNA Officers in Chicago. In 1970, Chicago had more national UNA officers than any other city in North America. From left to right are Andrew Jula, John Evanchuk, Myron B. Kuropas, Peter Pucilo, Helen Olek, Stephen Kuropas, and Taras Shpikula. All but Jula are Chicagoans. At the time, the UNA had over 89,000 members in North America.

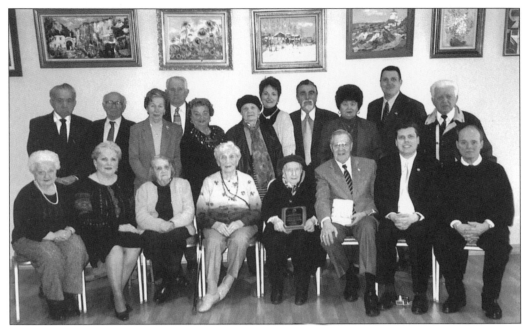

UNA District Committee Honors A UNA Pioneer. When Stefania Kochey reached age 100 in 2005, she was honored by the Chicago UNA District Committee for 53 years of service to the Ukrainian community as branch secretary of UNA Branch 472. Kochey is seated in the center. She is surrounded by UNA national executives, branch secretaries, and friends.

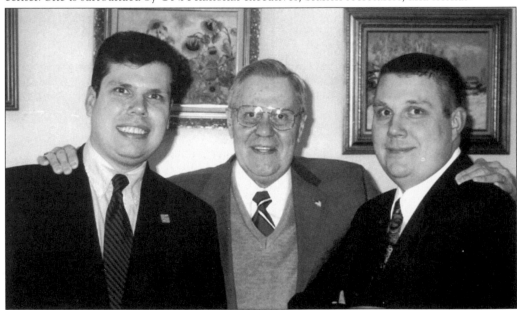

Like Grandfather, Like Father, Like Sons. These three UNA fraternalists include, from left to right, Stefko M. Kuropas, UNA vice-president (1998–2002), UNA district committee chairman, and UNA branch secretary of Branch 22; Myron B. Kuropas, national UNA vice-President (1978–1990); and Michael V. Kuropas, national UNA advisor (2002–2006). All three were following in the footsteps of Myron's dad, Stephen Kuropas, who served as UNA national vice-president from 1961 to 1970.

Three

FOR AN INDEPENDENT UKRAINE

Like most Ukrainians in the free world prior to 1991, Chicago's Ukrainians were committed to the re-establishment of a free, sovereign, and independent Ukrainian state. During World War I, Chicago's Ukrainian patriots struggled to gain American recognition for Ukraine, then a struggling nation. Unwilling to reconcile themselves to Ukraine's defeat and partition after the war, Ukrainians yearned for political ideologies that could provide hope for the future.

In 1919, the Communist Party of America was established in Chicago. Some Ukrainian socialists quickly created a Ukrainian Communist party branch to promote the idea that Soviet Ukraine was really an autonomous nation. With financial assistance from Moscow, a center was created on the corner of Chicago Avenue and Campbell Street, where party meetings and classes for illiterates were held. A choir, dance group, and youth affiliate were also established. Always loyal to the Soviets, the party remained active until the 1950s.

The Ukrainian Hetman Organization-Sich (UHO) was established in the 1920s as a challenge to Ukrainian Communists. Supported by the Ukrainian Catholic Church, UHO was committed to a constitutional monarchy under the rule of a "hetman." *Hetmans* (commanders) were elected by the *Kozak* (Cossack) Brotherhood in Ukraine during the 16th and 17th centuries. UHO published three newspapers in Chicago: *Sichovi Visti*, *Sich*, and *Nash Styakh*. Believing that they could create an army of liberation in America, young UHO members joined the U.S. militia (National Guard) and formed Company B of the 33rd U.S. division. They also purchased three airplanes to train pilots.

A second anti-Communist party, the Organization for the Rebirth of Ukraine (ODWU), affiliated with the Organization of Ukrainian Nationalists in Europe (OUN), challenged both the Communists and UHO. ODWU Branch No. 2 was established in Chicago in 1930, soon after the visit of OUN leader Evhen Konovalets to the city. Committed to the resurrection of a democratic Ukrainian republic with a freely elected president, ODWU created a youth affiliate, the Young Ukrainian Nationalists (MUN), and the Ukrainian Gold Cross for women.

Demonstrations and involvement in the American political process were also vehicles for Chicago's Ukrainians to promote Ukraine's aspirations.

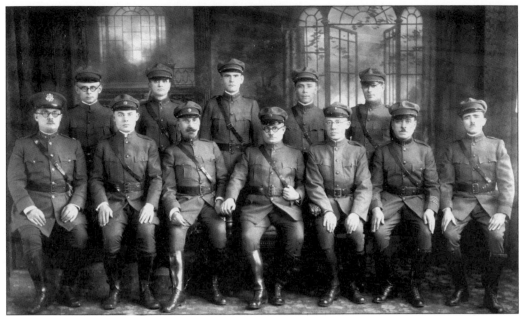

UHO Officers in 1923. Identified here are Dr. Myroslav Siemens (first row, left), Myroslav Melnykovych, Dr. Volodymr Simenovych (first row, third from left), the Supreme Ataman of UHO Dr. Stefan Hrynevetsky (first row, fourth from left), R. Boyko, V. Kuziv, Mykhailo Kushak, Martin Barabash, Pavlo Gudzej, and Ivan Shkraba. At the time, UHO members in Chicago were supporters of Hetman Pavlo Skoropadsky, who ruled Ukraine for a brief period during the first republic.

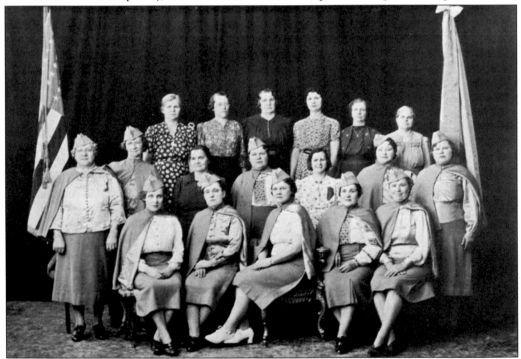

Company 8, UHO. Company 8 of the 2nd Division of the UHO was organized in January 1923 at the parish of the Blessed Virgin Mary (BVM) by Maria Bilyk and Catherine Mychancio.

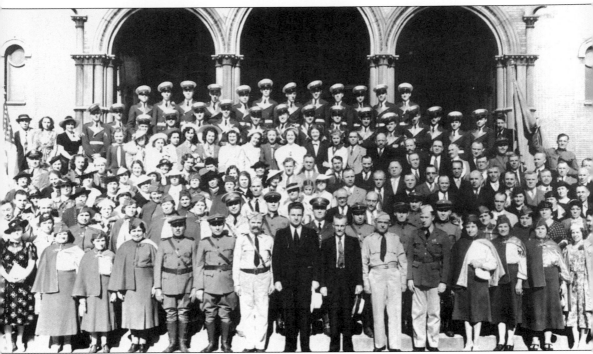

UHO Greets Hetmanych Skoropadsky in 1938. UHO invited Danylo Skoropadsky, the *hetmanych* (heir) of Hetman Pavlo Skoropadsky, to Chicago in 1937. The young Skoropadsky is standing in the center of the first row with the entire UHO contingent— men, women, and young "Seige" members—behind him. Standing sixth from the right in the first row is the uniformed John Duzansky, a leading Chicago businessman. To his right is Alexander Shapoval, supreme ataman. At the time, UHO members belonging to the National Guard were training pilots and holding maneuvers at St. Nicholas Cemetery. On December 17, 1933, the UHO and a number of other organizations marching to protest the Stalin-engineered famine in Ukraine, were attacked by Communists throwing rocks and wielding lead pipes and brass knuckles. "100 Hurt in N.W. Riot" declared the *Chicago Tribune*. "Mainly with the aid of Ukrainian Seige (sic) guards who used clubbed rifles, police within five minutes routed the Reds and quelled the fighting," the *Tribune* explained. Similar clashes between Communists and Ukrainian patriots were a regular occurrence during the 1920s and 1930s.

MEMBERS OF BRANCH NO. 2 OF MUN IN 1935. MUN (Young Ukrainian Nationalists) was an organization affiliated with ODWU. Seated in the center in the light suit is John Sawchyn, who was national president of MUN at the time. The Chicago MUN branch published *Trident*, a youth journal in the English language during the 1930s and 1940s and the *Trident Quarterly* during the 1960s.

MEMBERS OF BRANCH NO. 2 OF THE ODWU IN 1947. From left to right are T. Nosiewych, Dr. A. Gajecky, M. Bihun, S. Kuropas, B. Popadiuk, A. Iwaniw, M. Laba, and S. Pankiw. Between 1960 and 2000, ODWU Branch No. 2 owned a book store and a printing press in Ukrainian Village where *Independent Ukraine*, edited by Stephen Kuropas, was published. ODWU is affiliated with the Organization of Ukrainian Nationalists (OUN-M), once led by Col. Andrew Melnyk.

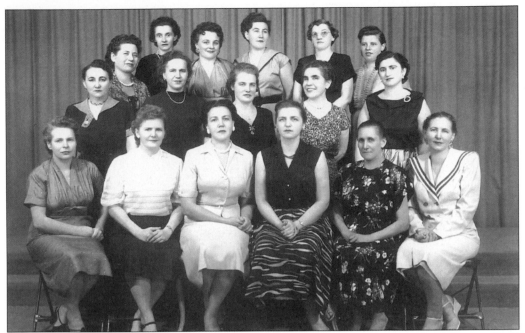

MEMBERS OF THE UKRAINIAN GOLD CROSS, BRANCH NO. 12 IN 1956. The Ukrainian Gold Cross was the women's auxiliary of ODWU. Seated in the first row, third from the left, is the branch president, Antoinette Kuropas.

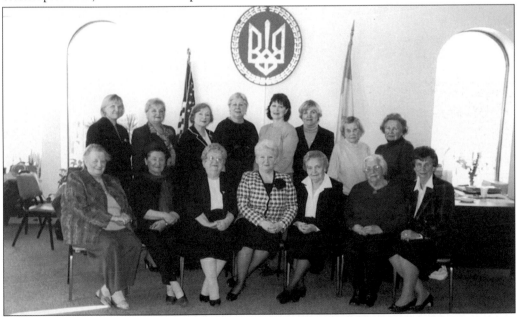

UKRAINIAN NATIONAL WOMEN'S LEAGUE OF AMERICA (SOYUZ UKRAINOK). A women's organization that remains politically neutral in Chicago is the Ukrainian National Women's League of America (UNWLA), a nationwide organization, *Soyzuz Ukrainok* in Ukrainian. Chicago's first UNWLA branch, No. 36, was established by Ann Brudny on Chicago's South Side in 1932. The UNWLA currently has seven branches in the Chicagoland area. Seen here are members of the UNWLA District Committee.

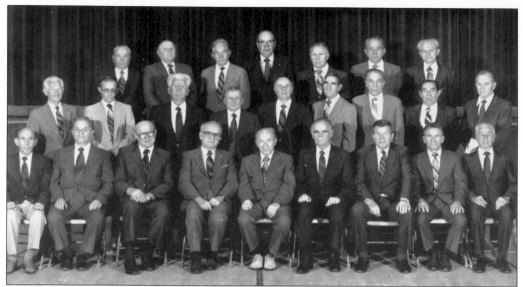

ORGANIZATION FOR THE DEFENSE OF FOUR FREEDOMS FOR UKRAINE (OOCHSU). The OCCHSU is affiliated with OUN(B), once led by Stefan Bandera. The first OOCHSU branch in Chicago, whose members are seen here in this 1988 photograph, was established in 1949. A second OOCHSU Branch was established in West Pullman in 1952.

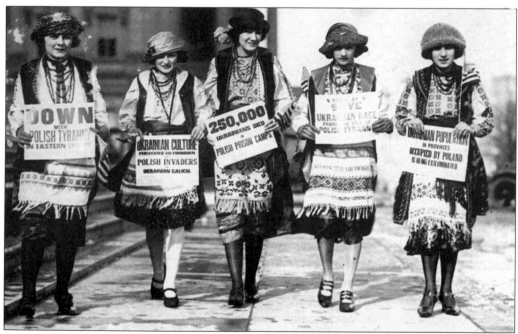

PROTESTING POLISH PACIFICATION. Ukrainian women in Chicago protested Polish repression in 1930. After World War I, western Ukraine was under Polish rule. As Ukrainian resistance to Polish rule increased, the Polish government initiated a "pacification campaign." Ukrainian-language elementary schools, gymnasiums, a Ukrainian polytechnical institute, and the Ukrainian Free University were forced to close. Ukrainian enrollment at the University of Lviv was drastically reduced, and governmental control of the Ukrainian Church was increased.

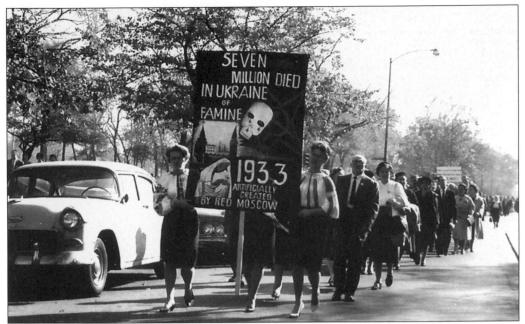

REMEMBERING THE FAMINE-GENOCIDE IN UKRAINE. Marching down Kedzie Avenue, Ukrainians in Chicago commemorated the 30th anniversary of the famine/genocide of 1932–1933, an artificial famine organized by the Soviets, with a manifestation and procession in 1963. During the height of the genocide, Ukrainians were dying at the rate of 25,000 per day. The Soviets, meanwhile, were exporting nearly 400 pounds of grain for each person who died.

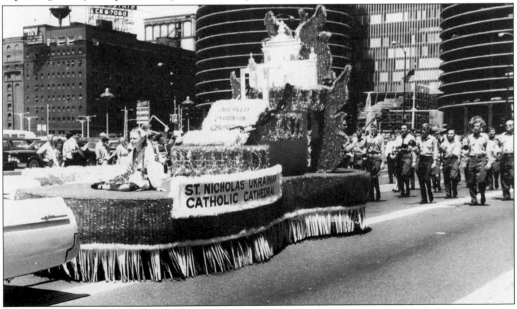

PROTESTING SOVIET PERSECUTION OF UKRAINIAN CHURCHES. St. Nicholas Ukrainian Catholic Church built this float for the 1966 Captive Nations parade in downtown Chicago. The message reads, "Enslaved Ukrainian Churches." The U.S. Congress, by Joint Resolution approved on July 17, 1959, authorized and requested the president issue a proclamation designating the third week in July of each year as "Captive Nations Week."

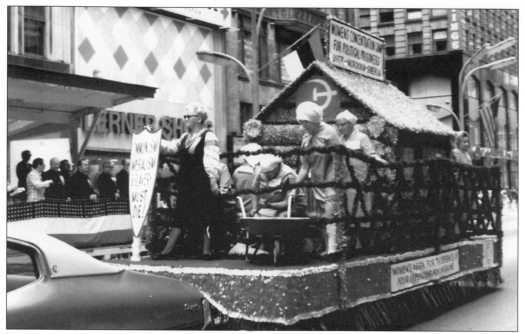

PROTESTING SOVIET IMPERIALISM. Shown is a parade float during the 1976 Captive Nations parade in downtown Chicago. Constructed by the Women's Association for the Defense of Four Freedoms in Ukraine, an affiliate of OOCHSU, the sign reads "Communist Imperialism and Slavery Must Die!"

RECALLING NAZI CRUELTY IN UKRAINE. In 1999, 54 years after his liberation from a Nazi concentration camp, Nick Stashko, a member of the League of Ukrainian Political Prisoners of German Concentration Camps, still has his camp tattoo. Born in western Ukraine, Stashko joined OUN(B) while a student. He was arrested by the Gestapo and spent time in Auschwitz and other Nazi concentration camps.

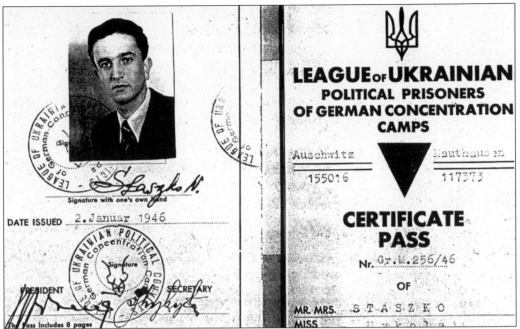

A **SELECT GROUP OF CAMP SURVIVORS.** This identity card was issued to Nick Stashko on January 2, 1946. Thousands of Ukrainians were either murdered by the Nazis during World War II, or were sent to slave labor camps where most perished. The two Ukrainian nationalist organizations in Ukraine, OUN(M) and OUN(B), established underground partisan units to fight the Nazis and the Bolsheviks during World War II.

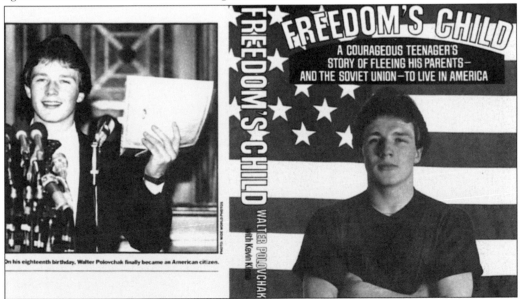

DEFENDING WALTER POLOVCHAK, "AMERICA'S LITTLEST DEFECTOR." Walter Polovchak was 12 years old in 1980, when he joined his 18-year-old sister in refusing to return to Soviet Ukraine with his parents. Granted temporary political asylum by the courts, he was defended by a legal team headed by attorney Julian E. Kulas. Court procedures were dragged out by the Reagan administration until Walter was 18 and eligible for U.S. citizenship.

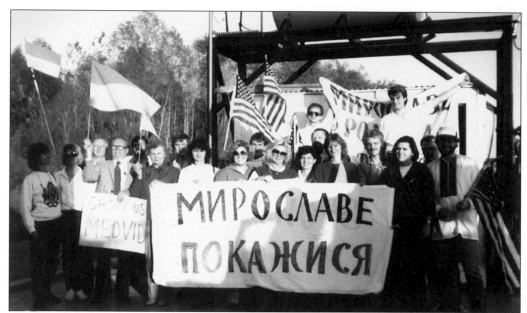

DEMANDING ASYLUM FOR A UKRAINIAN SAILOR. In 1985, Ukrainian sailor Myroslaw Medvid jumped from a Soviet freighter docked in New Orleans seeking asylum. When he was returned to his ship, Chicagoland Ukrainians rushed to Louisiana to protest. The sign reads, "Myroslaw, Show Yourself." Protestors included Natalka Zavadovych, Marika Jackiw-Webb, Vera Eliashevsky, Irene Dziuk, Oles Rojnarowich, Roman Golash, and Taras Jarworsky. Medvid survived, visiting Chicago as a Catholic priest in 2001.

REMEMBERING SERVICE TO UKRAINE. The Ukrainian Veterans Organization was established to bring together all those who served in the Ukrainian military during two world wars. This photograph is from 1955.

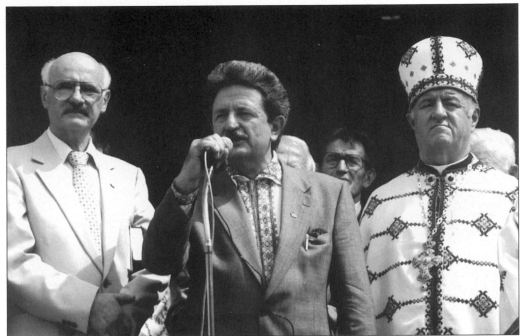

MIKHAILO HORYN IN CHICAGO. In 1989, Ukrainian dissidents in Soviet Ukraine formed *RUKH* (movement), a human rights society aimed at gaining freedom and autonomy for Ukraine. One of the leaders was Mykhailo Horyn, shown addressing Chicago Ukrainians in this 1990 photograph with Dr. Bohdan Tkachuk (left), chairman of RUKH in Chicago, and Rev. Mitrat Marian Butrynsky, pastor of SS. Volodymyr and Olha Ukrainian Catholic Church.

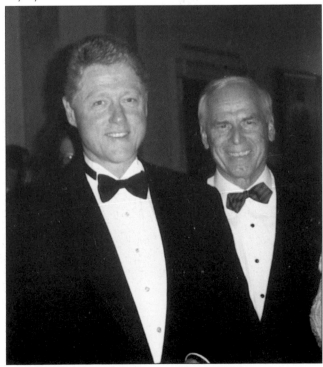

UKRAINIAN DEMOCRATS IN CHICAGO. Julian E. Kulas, a lifelong Democrat, leader of Ukrainian Democrats locally and nationally for many years, works to gain recognition among leading Democrats for the Ukrainian cause. Here is Julian standing to the left of Pres. Bill Clinton.

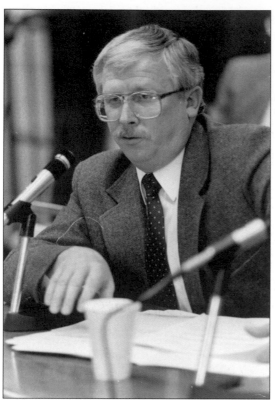

MYRON KULAS, STATE REPRESENTATIVE. Born in Ukraine, Myron J. Kulas came to Chicago with his family in 1950. A graduate of St. Nicholas Elementary School, he earned his bachelors degree from Loyola University in 1967. He was a Democratic member of the Illinois State Assembly from 1979 to 1993, representing the 10th district. He served as chairman of the House Energy and Environment Committee for eight years.

SEN. WALTER DUDYCZ. Sen. Walter Dudycz, a Republican, represented the 7th District in the Illinois Senate since 1985 and was named assistant majority leader in 1993. A graduate of the Chicago Police Academy, he received a bachelors degree from Northeastern Illinois University and served in the U.S. Army, including a 12-month tour in Vietnam. A Chicago policeman since 1971, he retired with the rank of detective in 2000. He was named executive director of the Illinois Racing Board in 2002.

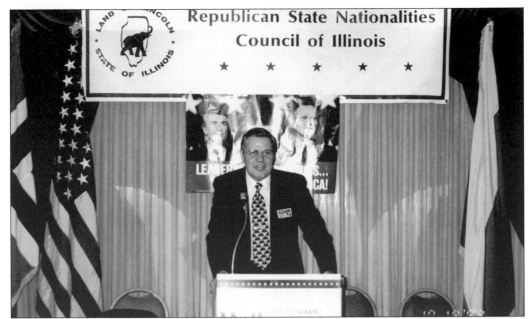

UKRAINIAN REPUBLICANS IN CHICAGO. Myron B. Kuropas, founding member and first president of the Republican State Nationalities Council of Illinois, is shown here in 1992. Kuropas was appointed Great Lakes Regional Director of ACTION, a federal agency devoted to volunteer development. He created Senior Ethnic Find, a VISTA (Volunteers in Service to America) program assisting ethnic seniors in Illinois, Michigan, Indiana, and Ohio.

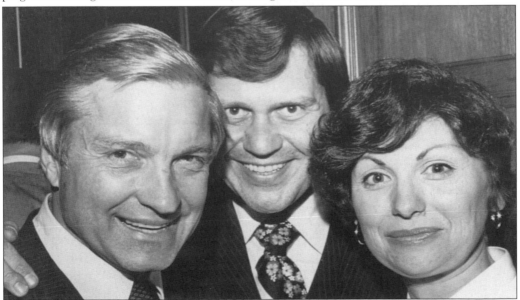

SEN. CHARLES H. PERCY AND CHICAGO UKRAINIANS. Myron and Lesia Kuropas are with Sen. Charles H. Percy (Republican in Illinois) in 1977. Chairman of the Senate Committee for Foreign Relations (1981–1985), Senator Percy held hearings and pushed legislation through the Senate, which led to the creation of the U.S. Commission on the Ukraine Famine. Myron served on the commission, which concluded in 1988 that Stalin "committed genocide against Ukrainians in 1932–33."

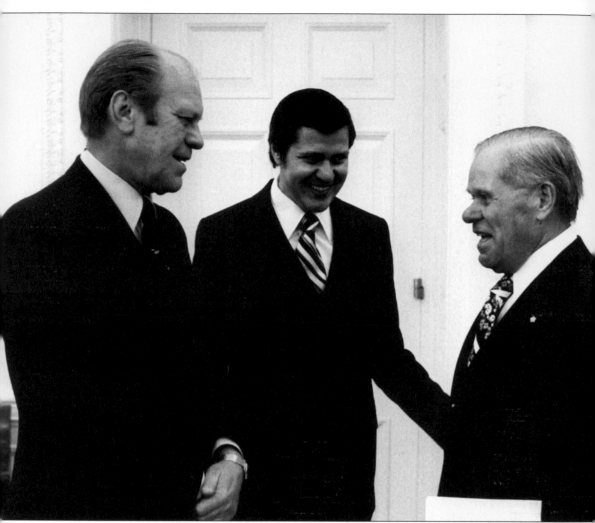

"MR. PRESIDENT, MAY I PRESENT MY DAD." Dr. Myron B. Kuropas (center), special assistant to the President for Ethnic Affairs, is seen in this 1976 photograph introducing his father, Stephen Kuropas (right), to Pres. Gerald R. Ford (left). Dr. Kuropas organized four White House conferences dealing to ethnic issues: neighborhood revitalization, ethnic studies in American schools, the inclusion of ethics in the 1980 census, and mental health among ethic Americans. Cochairman of the Ukrainian-Jewish dialogue in Chicago, Dr. Kuropas received an award from the American Jewish Committee in 1979 "for recognizing and respecting the diversity of all groups within our society and for helping to bring these groups together for the betterment of all mankind."

Four

EDUCATION, YOUTH, SPORTS

Preserving the Ukrainian heritage by educating the next generation remains an important aspect of Ukrainian community life. An ethnic school for the purpose of "perpetuating the Rusyn heritage" was first discussed at a St. Nicholas parish council meeting as early as 1906, but it was not until the arrival of Father Strutynsky that a *Ridna Shkola* ("national school") was formally established. By 1909, the parish was willing to pay $50 a month for a *diakuchechtyl* (cantor-teacher) who, in addition to his duties as a cantor during divine liturgy, was also responsible for the organization and direction of a choir, a drama group, and a heritage school.

A modest Ridna Shkola was organized in 1907 with one teacher and 10 students who attended one evening a week, and Saturday from 10:00 a.m. to noon. By 1922 there were four teachers, some 300 students, and a Ukrainianization program that was in operation five days a week, Monday through Friday from 4:00 p.m. to 6:00 p.m. St. Nicholas Church parish built a day school in 1936 and expanded it in 1954. Another day school was opened at BVM parish on the South Side in 1956.

Today Ukrainian Catholic and Orthodox parishes as well as other organizations operate after-school programs and Saturday schools that teach Ukrainian language, literature, history, geography, and culture. Youth activities have become a must for new parishes. The success of each program depends on the skills of the teachers and their ability to reach an increasingly American-born student body. Ukrainian Saturday school students attend classes for 11 years. Before graduating, they must gain their *matura* by passing rigorous written and oral examinations.

Ukrainian youth organizations in Chicagoland are also an important aspect of the Ukrainian preservation effort. They sponsor choirs, dance groups, sports teams, and a variety of activities to encourage young people to remain close to their ethnic heritage.

DMYTRO ATAMANEC, DIAKUCHETYL. Dmytro Atamanec, a diakuchetyl at St. Nicholas Church, played an important role in the Ukrainianization of the younger generation. His responsibilities included singing the responses during liturgies, organizing a choir, and teaching Ukrainian history, culture, geography, and literature to parish youth. When Atamanec took over as teacher in 1922, there were only 40 students. By 1924, a total of 520 students were enrolled.

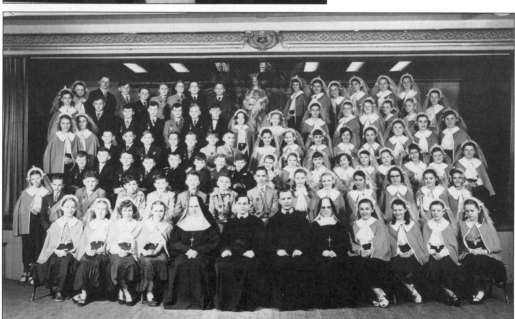

ST. NICHOLAS SODALITY. The arrival of third-wave Ukrainian immigrants to Chicago expanded the school population at St. Nicholas School, which had many student organizations including this sodality, shown here in this 1951 photograph. The teaching staff, all members of the Basilian Order of priests and nuns, include, from left to right, Sr. Mary Nataly, moderator; Fr. Wolodymyr Gavlich, pastor; Fr. Myron Horishny, moderator; and Sr. Mary Neonilia, school principal.

ST. NICHOLAS DAY SCHOOL. The St. Nicholas Elementary School complex in 2006 takes up half the block on Rice Street, east of St. Nicholas Cathedral.

UKRAINIAN PRE-SCHOOL. Ukrainian youngsters are never too young to learn about their heritage. In this 1992 photograph, Alexandra Mudry and Stephania Halamay are teachers at *Sadochok Dzvinochok*, a kindergarten class housed at the SS. Volodymyr and Olha Ukrainian Cultural Center.

ST. NICHOLAS UKRAINIAN SATURDAY SCHOOL BEGINNERS. Serious Ukrainian studies have already begun for these students at Ukrainian Saturday School housed at the St. Nicholas church hall. Marta Stadnyk and Yuriy Viktiuk, seen in this 1992 photograph, are just two of the many teachers who have worked with Ukrainian youth over the years.

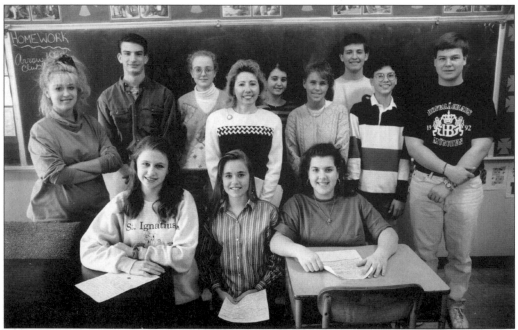

UKRAINIAN SATURDAY SCHOOL. In this 1994 photograph, teacher Christine Taran stands with graduates of the Ukrainian Saturday school housed at St. Nicholas School.

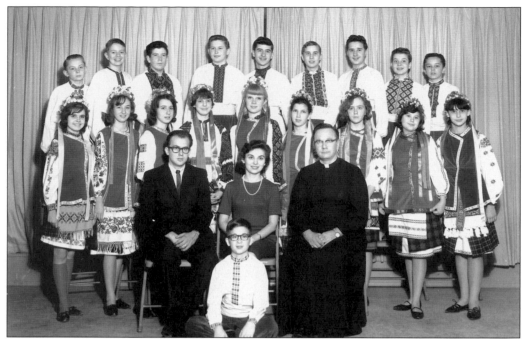

UKRAINIAN HERITAGE COURSES AT ST. JOSEPH. In 1965, these young parishioners at St. Joseph's Ukrainian Catholic Church learned Ukrainian singing from Alexandra "Lesia" Kuropas, seated in the center, and dancing from Johnny Lewkowicz, seated to the left. The pastor, Fr. Joseph Shary, is seated to the right.

UKRAINIAN BALLET SCHOOL. Located in the SS. Volodymyr and Olha Ukrainian Cultural Center, the Ukrainian Ballet School was led by Roxana Dykyj-Pylpczak and Marta Horodylowsky-Kozyckyj in 1996.

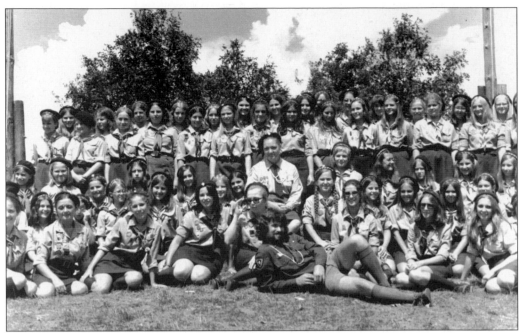

UKRAINIAN GIRL SCOUTS (PLAST). Third-wave immigrants brought many organizations with them to Chicago, including *Plast* (scouts), the Ukrainian Youth and Camping Organization. This 1972 photograph shows Ukrainian female scouts at the Chicago Plast camp in Westfield Wisconsin. There were 61 scouts with 10 leaders. Seated in the center is Halya Zajac, the camp commandant.

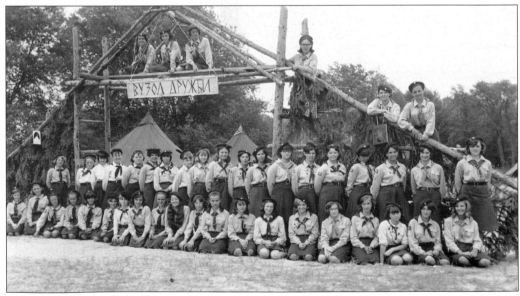

PLAST GIRLS AT WORK. Plast girl scouts constructed an entrance to their camp grounds that, literally translated, reads, "Knot of Friendship."

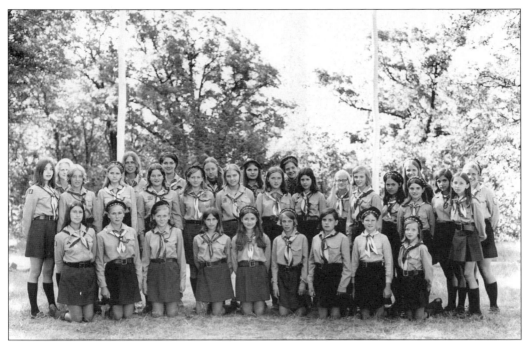

PLAST GIRLS AT CAMP. During the 1970s and 1980s, Plast provided a well-rounded outdoor education experience for many young Chicagoans.

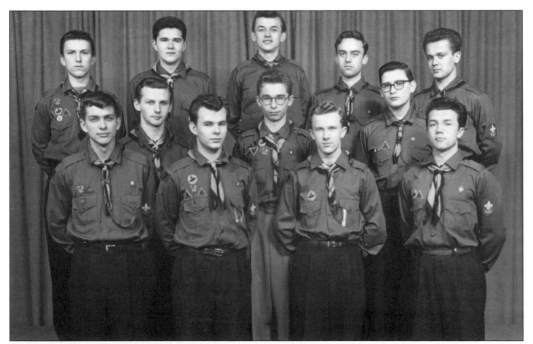

PLAST ELKS. Plast units had many names including elks, seen here in 1957. From left to right are (first row) Jaropolk Bilynskyj, Jaroslaw Martyniuk, Jurij Ozga, and Rostyslaw Bojkowycz; (second row) Lubomyr Klymkowych, Myron Komarynsky, and Jurij Kuzycz; (third row) Aleksander Pleshkewycz, Rostyslaw Klukowsky, Zenon Forowych, Ivan Gula, and Slawomyr Pihut.

UKRAINIAN STUDENTS CLUB AT THE UNIVERSITY OF ILLINOIS. Seated in the center of this 1966 photograph of the University of Illinois Ukrainian Students Club is Boris Antonovych, president, who later became an attorney in Ukrainian Village and served one term (1976–1978) in the Illinois House of Representatives. Faculty moderators were professors Dmytro Shtogryn, seated at the far right, and Nick Britsky, seated at the far left.

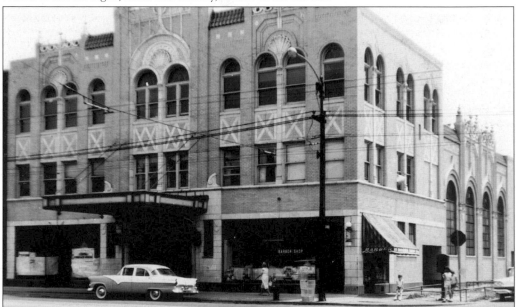

SUM IN CHICAGO. Another youth organization brought over from Europe was SUM, known in Chicago as the American-Ukrainian Youth Association. With "God and Ukraine" as their motto, SUM leaders emphasize education, sports, music, and dance. Located in this Ukrainian Village building at 2457 West Chicago Avenue, the Pavlushkiv branch of SUM is one of the most active in the nation with dance group Ukraina, a choir, and sports teams, which go under the name Wings.

SUM Leaders in Chicago. This 1970s photograph of older SUM members was under the leadership of Stefan Golash, the gentleman seen in the upper right-hand corner in a white shirt. During World War II, Golash served in the Ukrainian Insurgent Army, which fought the Nazis and the Soviets.

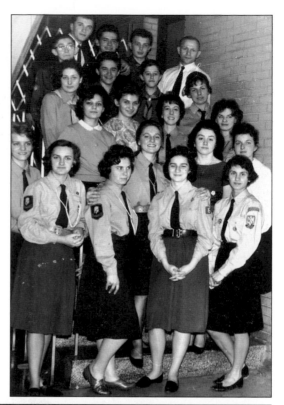

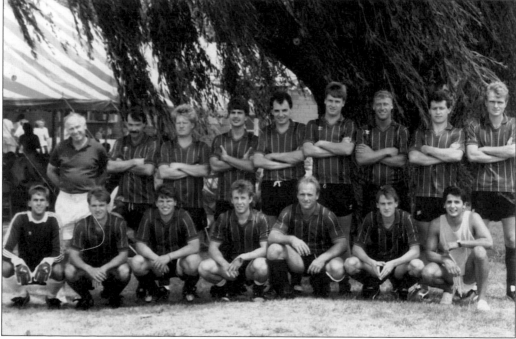

SUM Soccer Team Wings. This SUM soccer team, Wings from the 1970s, was coached by Julian E. Kulas, seen standing to the far left in the second row. His son was also a member of the team. Today, both share a law office in Ukrainian Village.

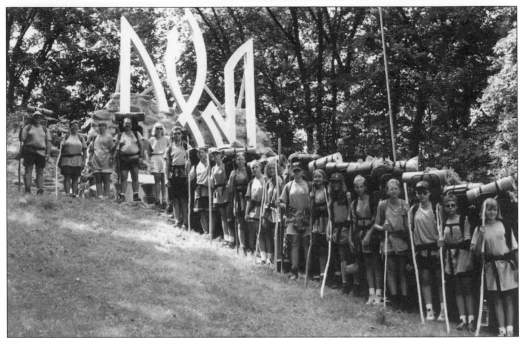

SUM Campground and Resort. SUM maintains a 142-acre campground and resort in Baraboo, Wisconsin. The site includes a dormitory, a 25-room motel for guests and visitors, a dining hall, an assembly hall, tennis and volleyball courts, an outdoor swimming pool, two full-size soccer fields, and a campground for SUM youth from the Midwest. Standing next to the SUM emblem, these campers are ready to go hiking.

OOCHSU Branch No. 31 in Palatine. The Ukrainian Center in Palatine, located at Illinois Avenue and Benton Street, is the home of OOCHSU Branch No. 31, established in 1958, as well as the Dmytro Vitovsky branch of SUM. The hall also serves as a rehearsal center for Dnipro, a mixed choir sponsored by OOCHSU and SUM.

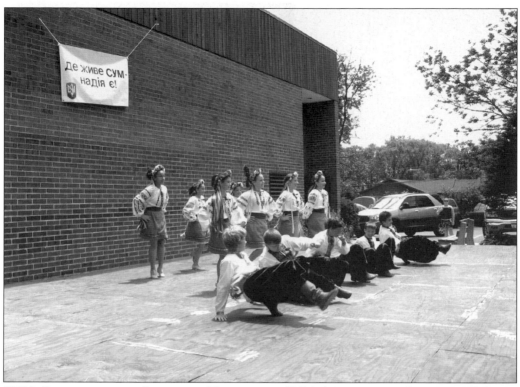

SUM Celebration in Palatine. These young SUM dancers are performing in Palatine during SUM Day in 2006. The sign reads, "Where there is SUM, there is hope."

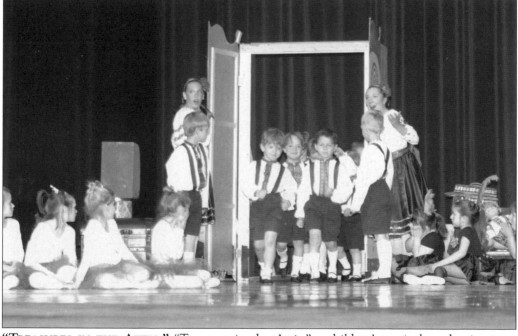

"Treasures in the Attic." "Treasures in the Attic," a children's musical production, was performed by the Palatine SUM members at Elgin Community College on Mothers' Day, 2006.

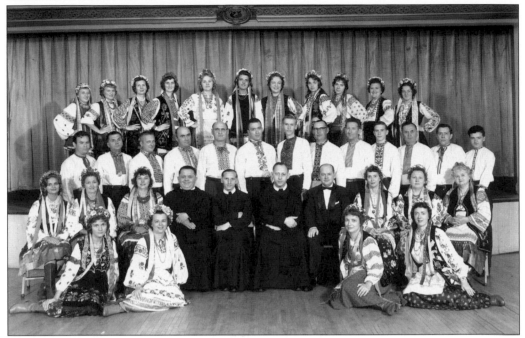

St. Nicholas Church Choir. The St. Nicholas Church choral tradition was very much alive in 1961. The priest seated in front, second from left, is Fr. Innocent Lotocky, who later became Bishop Lotocky.

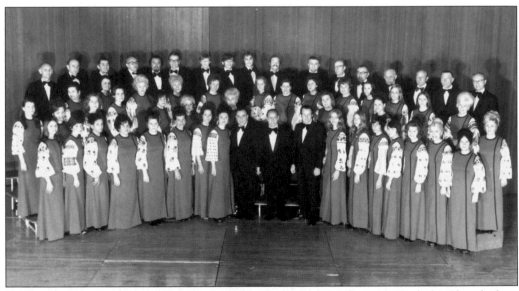

St. Joseph Church Choir. During the 1970s, the St. Joseph Ukrainian Catholic Church choir was under the direction of Julian Pozniak (first row, center). To his left is Jaroslaw Stefaniuk, who directed the St. Joseph women's choir. Every woman embroidered her own blouse following a pattern common in Kyiv. The rest of the costume, the *zhupan*, was sewn by Anna Kulczycky according to the individual measurements of each woman.

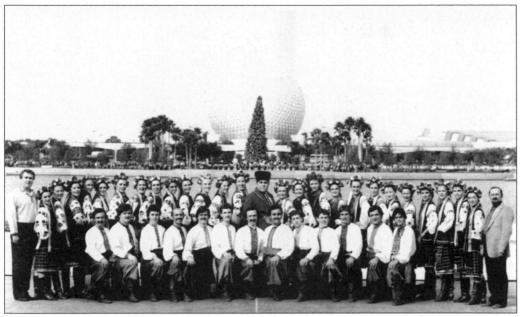

UKRAINIAN DANCE GROUP UKRAINA. Ukrainian folk dancing has been part of the cultural scene in Chicago since the 1930s. The pride of Chicago SUM has always been the dance group Ukraina, established in 1950. The dancers have performed at Chicago's Auditorium Theater and throughout the United States and Ukraine. This photograph shows the group at the Walt Disney Epcot Center in 1983. Director at the time was Evhen Litvinov.

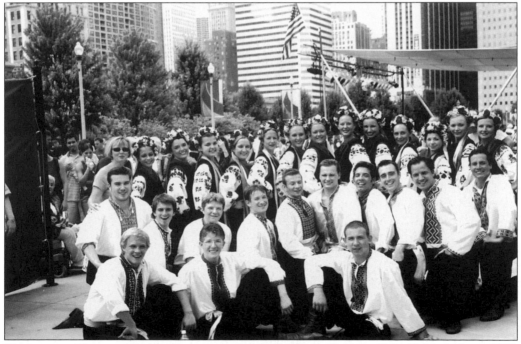

UKRAINIAN DANCE GROUP HROMOVYTSIA. Founded by Roxana Dyka-Pylypchak in 1979, Hromovytsia has performed throughout the United States, Canada, and Ukraine. It is shown here during opening ceremonies for Chicago's Millennium Park in 2005.

KATERYNA YUSCHENKO (NÉE CHUMACHENKO), UKRAINE'S FIRST LADY. Born in Chicago, Kateryna Chumachenko, shown here in this White House photograph, was once a member of Palatine SUM, attended Ukrainian Saturday School, and was a SUM dancer. She completed a bachelor of science in International Economics at Georgetown University and became the director of the Ukrainian National Information Service (UNIS) of the Ukrainian Congress Committee. In 1986, she received a master's degree in International Finance and Public Non-Profit Management from the University of Chicago. She later worked in the U.S. State Department (1986–1988), the White House Office of Public Liaison (1988–1989), and the U.S. Treasury Department (1989–1991). From 1991 to 1993, she served as cofounder and vice-president of the U.S.-Ukraine Foundation and directed the Pylyp Orlyk Institute in Kyiv. She met Viktor Yuschenko, future president of Ukraine, in 1993. They married in a small church ceremony in 1998 and have three children, Sophia, Chrystyna, and Taras. She is also stepmother to Viktor Yuschenko's two older children, Lina and Andriy. She became a citizen of Ukraine in 2005.

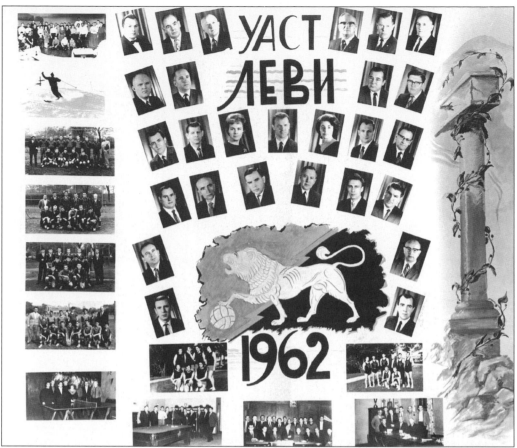

SPORTS CLUB LIONS. Founded in 1949, the Ukrainian American Sports Club Lions excelled in soccer but also sponsored a number of other sports activities such as tennis, Ping-Pong, and skiing.

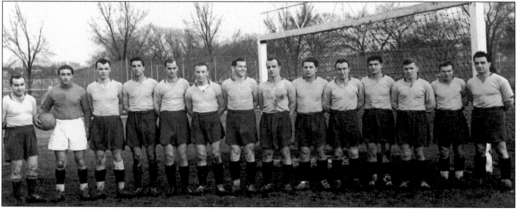

CHICAGO NATIONAL LEAGUE SOCCER CHAMPIONS, 1953. These Lions roared, capturing the 1953 Chicago National League Championship in 1953. From left to right are Bohdan Kucan, Mykola Kasian, Roman Andrushko, Ivan Tyshenko, Jurij Kochaniuk, Myron Diachniwsky, Vasyl Zarytskyj, Jurij Kuzyk, Victor Meleshko, Rostyslav Markewycz, Osyp Pundor, Orest Hladkij, Dmytro Stachrowskyj, and A. Shanasarian.

ROMAN ANDRUSHKO, ATHLETE/MUSICIAN/EDUCATOR. Born in Ukraine, Roman Andrushko is a Korean war veteran, a member of the 1953 championship Lions, and a musician. Music department chair at Senn High School, he also played bass for the Lyric Opera Orchestra, the Grant Park Orchestra, and the Dallas Symphony. He was a singer and director of the SURMA choir and is the director of the Prometheus Choir since its inception.

OLEH JOHN SKUBIAK, UNIVERSITY PRESIDENT. Associated with DeVry University's Keller Graduate School of Management since 1975, Oleh Skubiak was appointed president of DeVry University in 2004. Active in the Ukrainian community, he is a member of the Pobratymy Foundation, a fund-raising vehicle that provides financial support to Plast, the Ukrainian scouting organization.

IVANNA MARTYNIUK, MISS CHICAGO RUNNER-UP. Young Chicago Ukrainians also competed in beauty contests, as this photograph of Ivanna Martyniuk, third-place runner-up in the 1962 Miss Chicago contest, attests. Her married name is Dr. Ivanna Richardson. Today she is a practicing family therapist, president of the Friends of the Consulate General of Ukraine in Chicago, and for a time served as the chair of the education subcommittee of the Chicago-Kyiv Sister Cities Committee.

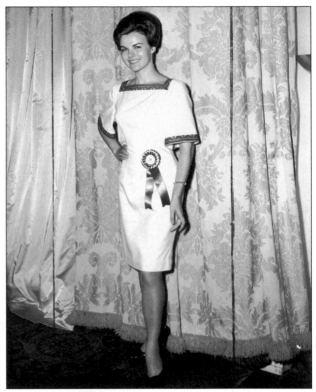

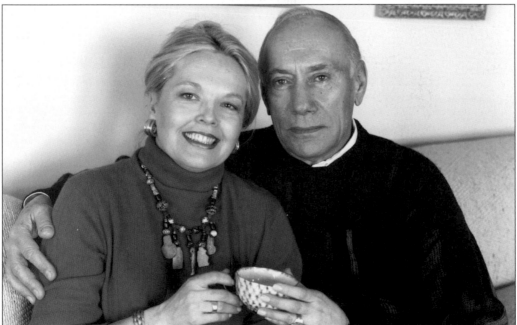

LIDA AND VASIL TRUCHLY. Among the many Ukrainian activist husband-wife teams in Chicago are Dr. Vasil and Lida Truchly, members of St. Andrew Ukrainian Orthodox parish. A retired gynecologist, Dr. Truchly is the director of the St. Andrew choir while Lida has been active with the Chicago-Kyiv Sister Cities Committee, serving as chair of the health subcommittee.

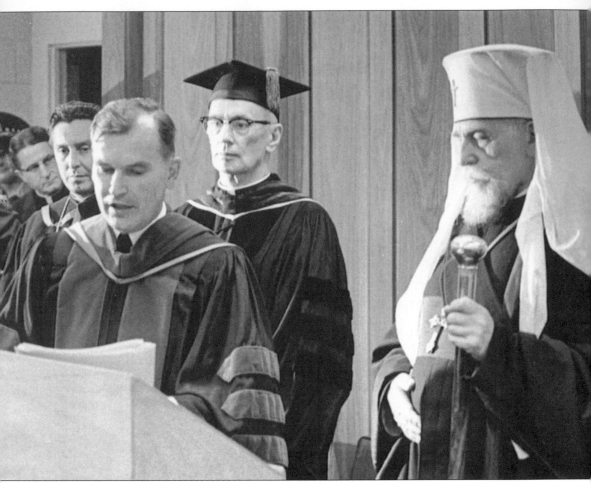

HONORING A MARTYR FOR THE FAITH. Cardinal Josef Slipyj received an honorary doctorate from Loyola University in 1968. Standing in academic regalia, from left to right, are Bishop Jaroslaw Gabro, Loyola professor Vasyl Markus, Loyola president Fr. Macquire, and Cardinal Slipyj, successor to Andrej Sheptytsky as Catholic archbishop of Lviv. Returning to Ukraine in 1944, the Soviets demanded that Catholic priests renounce their Catholic faith. Most refused and were sent to the *Gulag* (a series of Soviet concentration camps in Siberia). Metropolitan Slipyj was arrested in 1945 and offered the Kyivan metropolitanate of the Russian Orthodox Church. He refused and was sent to the Gulag. In 1946, the Soviets organized a phony synod of Catholic priests demanding that they "reunite" with the Orthodox Church of Moscow. Most refused and continued their ministry in the "underground church." Following 17 years of brutal imprisonment in Soviet labor camps, Archbishop Slipyj was released in 1963 and allowed to travel to Rome where Pope John XXIII welcomed him. He became a cardinal of the Catholic Church. Pope John Paul II beatified 25 Ukrainian Catholic martyrs for the faith during his visit to Ukraine in 2001.

Five

DRAMA, MUSIC, ART

Preserving and enriching the Ukrainian cultural heritage in Chicago was always an important goal of Ukrainian organizations. Drama groups, choirs, and instrumental ensembles helped keep Ukrainians close to their roots and appreciative of their rich traditions.

Ukrainians love to sing, and from the very beginning of their arrival in Chicago, they organized choirs, many of which won recognition and honors outside of the Ukrainian community. The 1922–1923 American tour of the famed National Chorus of Ukraine under the direction of Alexander Koshetz contributed greatly to the growth of Ukrainian-American choral societies. "Here was the noblest and austerest and most stringently moral thing in the world—perfection," wrote one American musical critic following a Koshetz concert. Unwilling to return to Ukraine following the Soviet occupation, Koshetz and many of his choir members elected to remain in the west. It was the Koshetz choir that introduced Americans to the now-popular Ukrainian Christmas classic "Carol of the Bells." During the winter months in Chicago, going to concerts to hear Ukrainian choirs perform was a Sunday afternoon event at the Chopin Public School in Ukrainian Village.

Another individual who contributed greatly to the flowering of Ukrainian culture in Chicago was Vasile Avramenko, a Ukrainian dance teacher who traveled around the United States and Canada organizing dance groups for Ukrainian youth. His involvement with the Ukrainian Pavilion at the Chicago World's Fair in 1933 and his song and dance concert at Chicago's Civic Opera House on November 8, 1931, are milestones of Ukrainian cultural history in Chicago. Bands and orchestras were also part of Ukrainian musical history in Chicago.

Ukrainian homes abound with original art. Local Ukrainian artists pursue successful careers as a result of the support they receive from the community. Thanks to the generosity of individual sponsors, art exhibits are a common feature of Ukrainian community life.

The Lysenko Choir of St. Nicholas Catholic Church in 1912. The choir was directed by Isidore Kostiuk, who is seated to the left of Fr. Nicholas Strutynsky (second row, center), pastor of St. Nicholas Church. To the right of Father Strutynsky sits the legendary Volodymyr Simenovych.

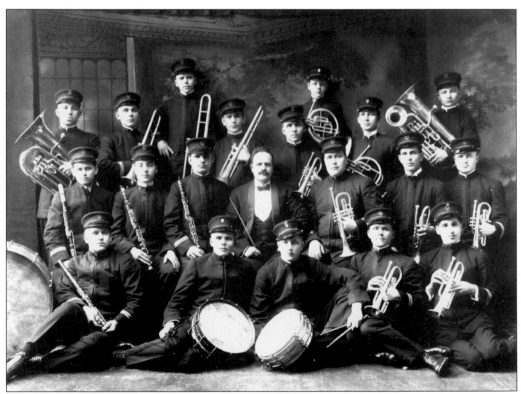

The Ukrainian Musical Society Band in 1917. The Ukrainian Musical Society Band was directed by Professor H. Edelman. This photograph dates back to February 1917.

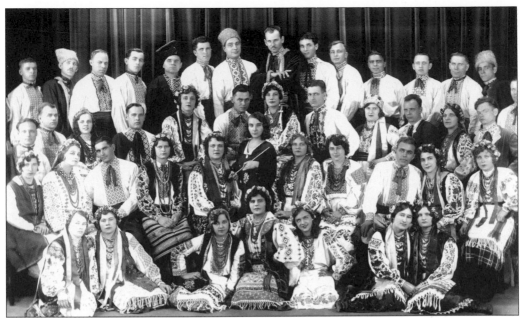

CHOIR OF THE HOLY TRINITY ORTHODOX CHURCH CHOIR IN 1915. This popular choir was directed by Natalia Hrynevetsky (née Pidliashetko), a former Viennese opera singer who married Dr. Stefan Hrynevetsky while he was pursuing his medical studies in Vienna. The Hrynevetskys settled in Chicago. A monarchist, Dr. Hrynevetsky was active in the UHO before he became disillusioned with Hetman Skoropadsky and left the organization.

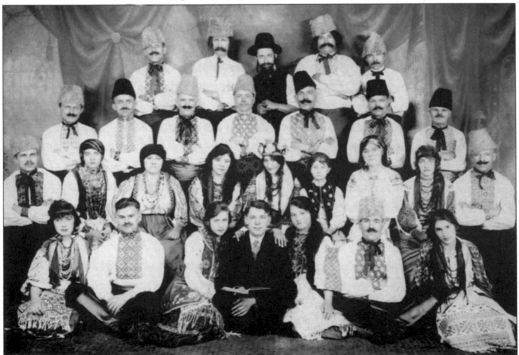

DRAMA GROUP OF THE HOLY TRINITY ORTHODOX CHURCH IN 1916. This drama group was another ensemble organized by the talented Natalia Hrynevetsky during her brief life.

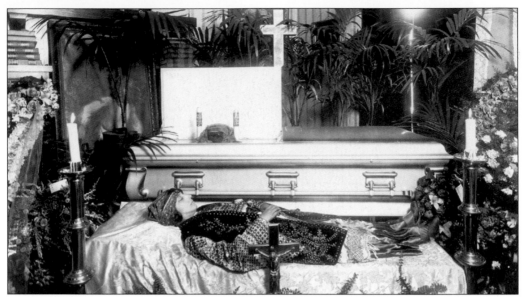

FUNERAL BIER OF NATALIA HRYNEVETSKY. The death of the beloved Natalia Hrynevetsy, a victim of the world-wide influenza epidemic of 1918–1919, was a devastating blow to Ukrainian cultural life in Chicago. Known as the Spanish Flu, the disease killed an estimated 675,000 Americans, 10 times as many as died in World War I.

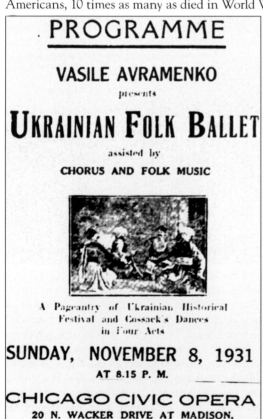

THE AVRAMENKO DANCERS DEBUT AT THE CIVIC OPERA HOUSE. This program book is from a November 8, 1931, dance concert performed by Vasile Avramenko and his Chicago dancers at Chicago's Civic Opera House. Over 300 dancers participated.

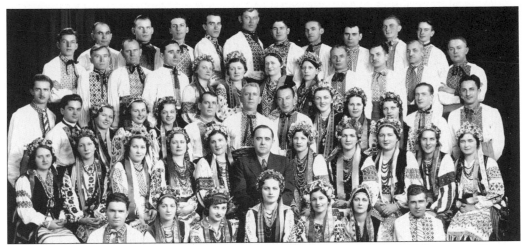

THE UKRAINIAN CHORUS OF CHICAGO. One of the cultural highlights of Ukrainian Chicago during the 1930s was the Ukrainian Chorus of Chicago. Competing with other choral ensembles in the annual Chicagoland Music Festival sponsored by the *Chicago Tribune*, the chorus won first place four times—twice under the directorship of Leo Sorochinsky (1930 and 1931) and twice under the directorship of George Benetzky (1932 and 1934). The chorus was founded in 1928.

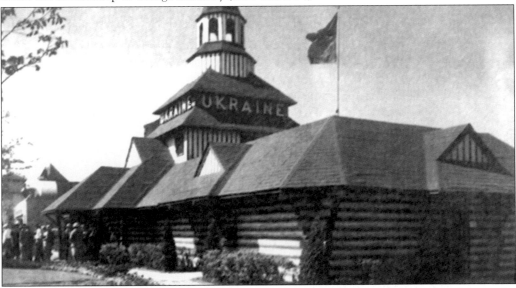

UKRAINIAN PAVILION AT THE CHICAGO WORLD'S FAIR, 1933. The Ukrainian pavilion at the Chicago World's Fair was the only national pavilion not sponsored by a foreign government. Despite vehement protests from Soviet Ukrainian authorities, the pavilion was approved by world fair organizers. The organizational committee worked closely with Ukrainians throughout the United States and Canada who sent cultural artifacts for display within the pavilion, which was officially opened on Sunday, June 25, 1933. Ceremonies included a six-block march to the pavilion by Ukrainians in national costume, an afternoon concert by the Ukrainian Chorus of George Benetsky, a dance performance organized by Vasile Avramenko, and a 95-piece orchestra recital directed by John Barabash. The pavilion was divided into three sections: general, historical, cultural; it also included a restaurant and open-air theater. Managing the entire operation were Volodymyr Levytsky, pavilion director; Stefania Chyzhovych, technical assistant; Volodymyr Stepankiwsky, publicity; and Marusia Beck, cultural assistant.

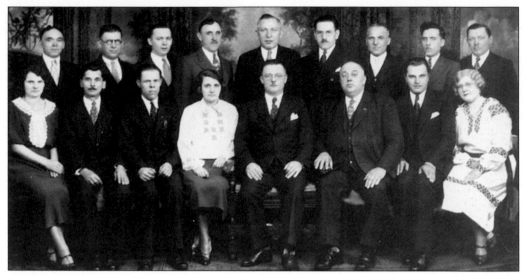

ORGANIZATIONAL COMMITTEE FOR UKRAINIAN PARTICIPATION AT THE 1933 CHICAGO WORLD'S FAIR. The Ukrainian organizational committee for the Chicago Worlds Fair included, from left to right, (first row) Mary Krechkiwsky; Jurij Nabor, financial secretary; Stephen Kuropas, secretary; Stefania Chyzowych-Pushkar, technical assistant; Dr. Myroslaw Siemens, committee chairman; T. Pikulsky; Taras Shpikula, treasurer; and Mae Mokritsky; (second row) Wasyl Lubas; A. Dragan; Peter Luczkiw; A. Kosovskyj; M. Kovalyk; John Barabash; M. Scherbatyj; Eugene Komanyshyn; and Leo Tyhanybik.

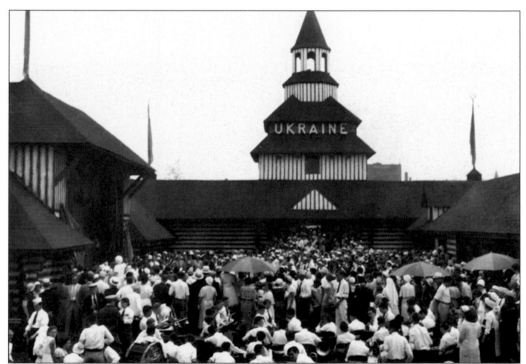

VISITORS TO THE UKRAINIAN PAVILION IN CHICAGO. The pavilion attracted some 1.8 million visitors during its short-lived existence.

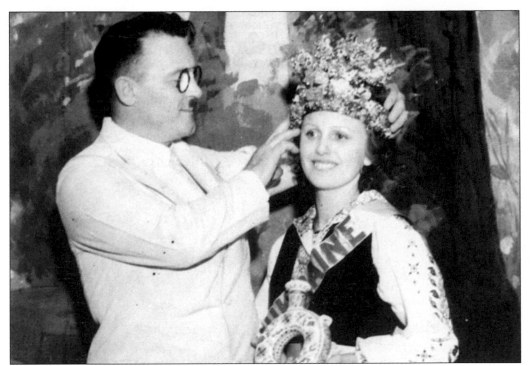

Miss Ukraine Crowned. Dr. Myroslaw Siemens crowns Maria Lubas as Miss Ukraine during the Chicago World's Fair.

Reception for Alexander Archipenko, World Famous Ukrainian Sculptor. The highlight of the Ukrainian pavilion's cultural section—divided into folk and modern art—was the exhibition of the world-famous Ukrainian sculptor Alexander Archipenko. This is a photograph of a reception held for the sculptor in the pavilion restaurant. He is seated in the center, surrounded by admirers.

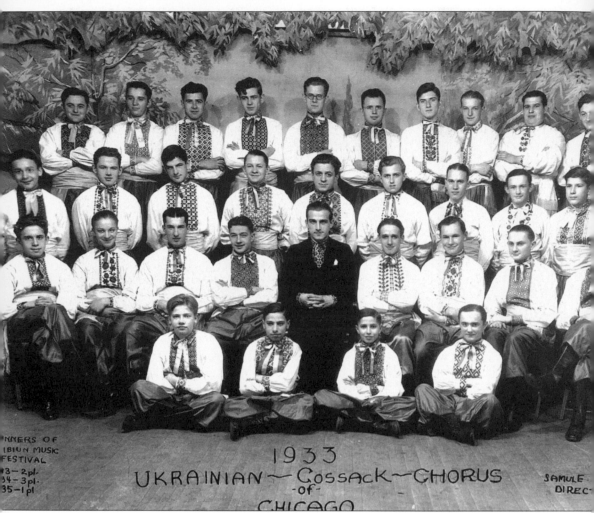

UKRAINIAN COSSACK CHORUS OF CHICAGO. Another outstanding choral group during the Depression was the Ukrainian Cossack Chorus shown here on stage at St. Nicholas Church auditorium in 1933. They also competed in the Chicago Tribune Music Festival, winning second place in 1933, third place in 1934, and first place in 1935. The group disbanded when most members went into the armed forces during World War II. From left to right are (first row) John Tkach, John Dytko, Jaroslaw Gabro (later to become the first Ukrainian Catholic bishop of Chicago), and Ted Stzym; (second row) Mike Kaniuga, Walter "Ed" Mokritsky, Joe Maryniak, Mike Demetriw, Samuel Czuba (director), John Holowczak, Steve Goshko, Joe Prietula, and Mike Bryowsky; (third row John Litwin, James Evankoe, Nicholas Matview, Mike Sawkiw, Mike Maziak, John Dubyk, Paul Marinoff, unidentified, and Andrew Diduch; (fourth row) Walter Bonakiwsky, William Petrow, John Haluzchak, John Hull, Walter Skoropad, Paul Kania, unidentified, Nick Wary, William Maryniak, and unidentified.

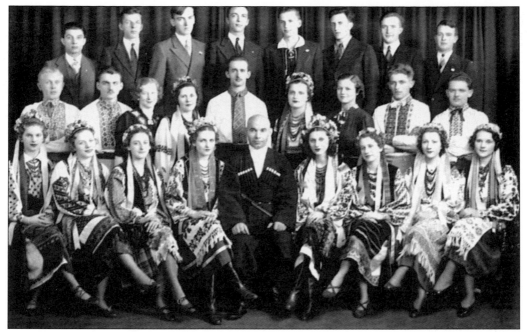

MIXED CHOIR OF MUN. The MUN choir, under the direction of Professor Yurchenko, seen here in the late 1930s, was forced to disband when many of its members left to serve in the U.S. armed forces during World War II.

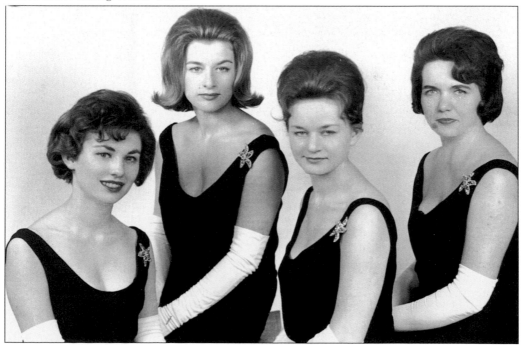

UKRAINIAN QUARTET. This popular Chicago vocal quartet, photographed in 1965, was under the direction of Dr. Volodymyr Kasaraba, a medical doctor with extraordinary musical talents. From left to right are Alexandra "Lesia" Kuropas, Myra Nahorniak, Tanya Nazarewicz, and Myroslawa Saldan.

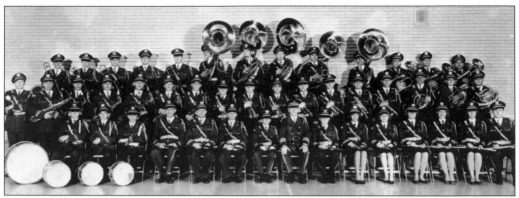

THE ST. NICHOLAS SCHOOL ORCHESTRA. The St. Nicholas orchestra in the 1960s was led by Capt. John Barabash, seated in the first row in the center. A talented music teacher and band director at Harrison High School for many years, John Barabash also directed the SUM band during the 1960s and 1970s.

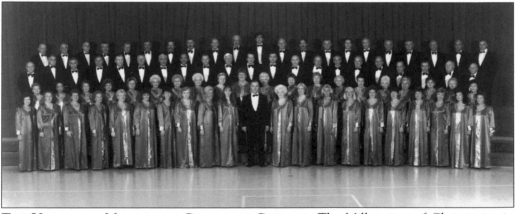

THE UKRAINIAN MILLENNIUM CHORUS OF CHICAGO. The Millennium of Christianity in Ukraine Chorus, pictured here in 1988, was a combined choral group of voices from various choirs in Ukrainian Chicagoland. It was under the direction of Roman Andrushko.

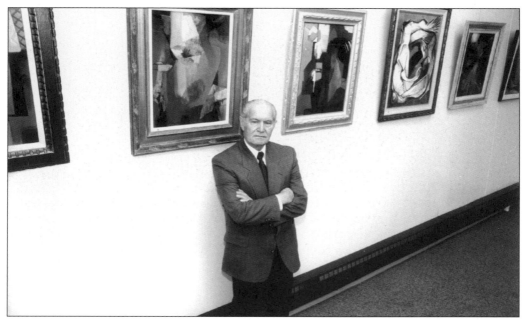

ANATOLE KOLOMAYETS—ARTIST. Born in Ukraine, Anatole Kolomayets, considered the "dean" of Ukrainian artists in Chicago, is a European-trained artist who came to Chicago in 1953. More than 400 of his works can be found in numerous private collections and galleries on four continents. He is one of the cofounders of the Ukrainian artist's group, Monolith of Chicago. There have been 33 individual exhibitions of his work.

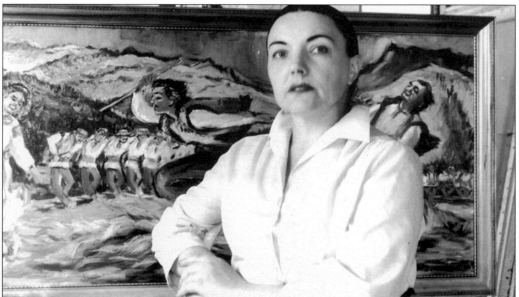

MARIA DACZYSZYN (NÉE HARASOWSKA), ARTIST. Ukrainian-born Maria Daczyszyn was one of many professionally trained artists who arrived in Chicago after the World War II. A popular artist, she exhibited throughout the United States and Europe. Her themes were landscapes, flowers, icons (Jesus and Mary primarily), and portraits. Her icons were often used for UNA Christmas cards. In 2000, First Security Bank published a 12-month calendar featuring her religious art.

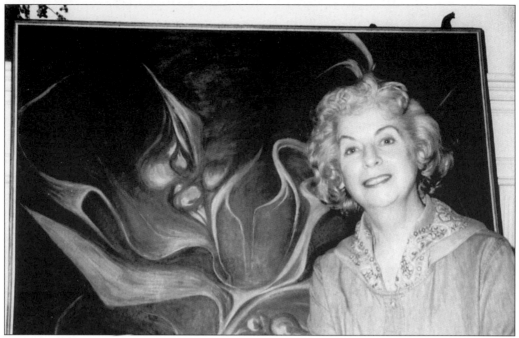

OKSANA TEODOROWYCZ, ARTIST. Ukrainian-born Oksana Teodorowycz arrived in Chicago with her parents in 1949. She received her bachelor of fine arts degree from the Chicago Art Institute. Her work has been exhibited in Chicago, Washington, D.C., Philadelphia, and Cleveland. The enamel "Virgin and Child" was presented to His Beatitude, Patriarch Cardinal Josef Slipyj. It is currently part of the permanent art collection of the Ukrainian Catholic University in Rome.

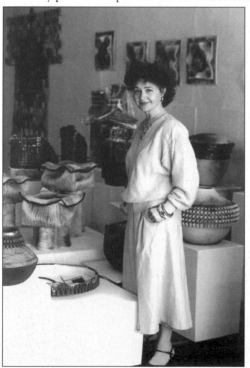

ALEXANDRA KOCHMAN, ARTIST. Ukrainian-born Alexandra Kochman is a painter and ceramist who holds a master of fine arts degree from the University of Illinois. A recipient of many art awards, her work can be found in many private and public collections including Chicago's Ukrainian Institute of Modern Art. She has taught at Dominican University since 1983 and has been a principal and teacher at the St. Volodymyr Ukrainian Saturday School since 1970.

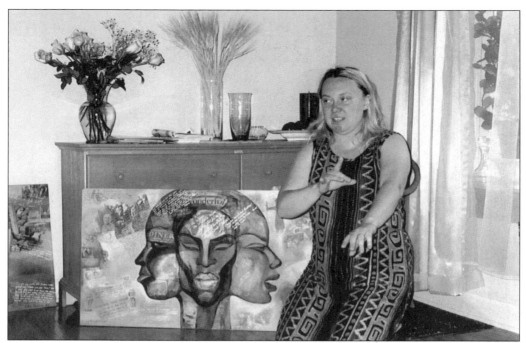

ELENA DIADENKO-HUNTER, ARTIST. Arriving from Ukraine in 1992, Elena Diadenko-Hunter completed a master of arts in teaching, becoming an art teacher at Roberto Clemente High School. She was awarded the Golden Apple Award for Excellence in Teaching in 2004, one of only 10 teachers to be so honored. In 2006, her work "Rebirth" was displayed at the Amsterdam-Whitney Gallery in New York City.

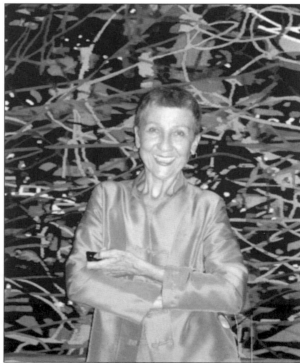

LIALIA KUCHMA, ARTIST/ PHOTOGRAPHER. Born in Ukraine, Jaroslava Lialia Kuchma was raised in Ukrainian Village. A tapestry artist and photographer, Kuchma spent eight years painting the interior of SS. Volodymyr and Olha Church under the direction of Maestro Dykyj—and documented each stage photographically. In 1998, she completed over 160 photographs for a collaborative publication with Irene Antonovych titled "Generations: A Documentary of Ukrainians in Chicago."

UKRAINIAN PYSANKY. Proud of their culture, Ukrainians love to share it with others. In this photograph, Alexandra "Lesia" Kuropas is making Ukrainian Easter eggs (*pysanky*) at the Northern Illinois University Folk Fair in 1993. Lesia has taught Easter egg making classes at the public library in DeKalb, Illinois, and Kishwaukee College in Malta, Illinois, as well as to her fourth-grade students at Lincoln Elementary School in DeKalb.

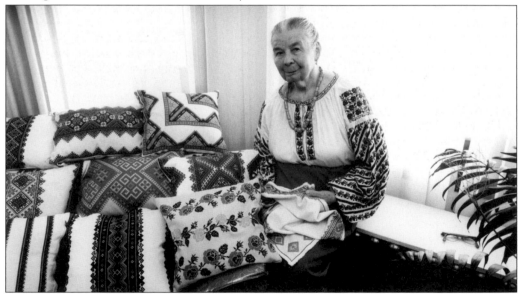

UKRAINIAN EMBROIDERY. Embroidery is another folk art practiced by Ukrainian women in Chicagoland. Anna Kuczma learned to embroider in Ukraine while a teenager and continued the art until age 90. The most popular of the folk arts, Ukrainian embroidery covers a wide scope of varied stitches, colors, and rich designs. Pillows, shirts, blouses, and icon cloths for the home are some of the traditional uses of Ukrainian embroidery.

Six

UKRAINIAN VILLAGE

It began as a dream, a vision first articulated by Dr. Volodymyr Simenovych in 1911. Urging St. Nicholas parishioners to buy land near Western Avenue (the city limits), where lots were plentiful and cheap, Simenovych spoke of "building a new Rus" in Chicago. Property was purchased to construct a church, and parishioners bought lots and built their homes in the area. Today the dream is a reality. Ukrainian Village is exactly where Dr. Simenovych believed it should be. In addition to three churches—St. Nicholas, St. Volodymyr, and SS. Volodymyr and Olha—Ukrainian Village consists of two Ukrainian financial institutions and various business and professional enterprises owned and operated by Ukrainians.

The heart of Ukrainian Village can be found in the ornate churches and the various cultural organizations that are headquartered in the SS. Volodymyr and Olha Cultural Center. The economic power of Ukrainian Village—the financial infrastructure that allows for preservation and development—are the two Ukrainian banks, which play a major role in preserving both the character and integrity of this unique area of Chicago. There was a time when land values were depressed and Chicago's downtown banks had "red-lined" the neighborhood. The two Ukrainian banks had no fears about the future. Their managers understood that loaning money to Ukrainians was a good investment because Ukrainians were frugal, trustworthy, and self-reliant.

Ukrainian Village, designated as a Chicago Landmark District neighborhood, is located between Damen Avenue on the east, Campbell Street on the west, Division Street on the north, and Superior Street on the south. The area was officially declared Ukrainian Village by Chicago mayor Jane Byrne on January 18, 1983, the first such designation in the city's history. Located near Wicker Park, the neighborhood has attracted many young professionals as well as members of other ethnic groups.

UKRAINIAN VILLAGE LOGO. Designed by Roman Zavadovych, this is the official logo of Ukrainian Village.

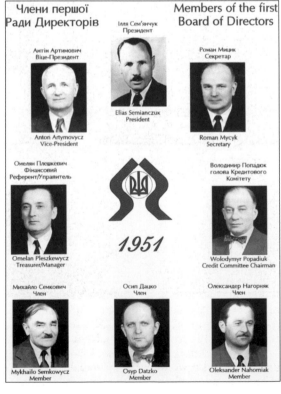

Члени першої Ради Директорів

Members of the first Board of Directors

Ілля Сем'янчук
Президент

Elias Semianczuk
President

Антін Артимович
Віце-Президент

Anton Artymovycz
Vice-President

Роман Мицик
Секретар

Roman Mycyk
Secretary

Омелян Плешкевич
Фінансовий
Референт/Управитель

Omelan Pleszkewycz
Treasurer/Manager

1951

Володимир Попадюк
голова Кредитового
Комітету

Wolodymyr Popadiuk
Credit Committee Chairman

Михайло Семкович
Член

Mykhailo Semkowycz
Member

Осип Дацко
Член

Osyp Datzko
Member

Олександер Нагорняк
Член

Oleksander Nahorniak
Member

FIRST BOARD OF DIRECTORS OF SELFRELIANCE FEDERAL CREDIT UNION. Barely four years after arriving in the United States, visionaries created a new institution to meet the financial needs of fellow Ukrainians. On July 2, 1951, the Illinois Credit Union League presented Federal Credit Charter No. 7346 to the newly elected Selfreliance Board of Directors. The name says it all. Ukrainians rely on themselves, and when they unite as a people, they can accomplish great things.

OLD SELFRELIANCE HEADQUARTERS. By 1955, Selfreliance had assets of $650,000 and a membership roll of 1,100. This building at 2351 West Chicago Avenue was purchased in 1957. During the 1960s, Selfreliance was able to provide 10-year mortgage and construction loans to members. Selfreliance assistance to Chicago Ukrainians led to 20 motels being purchased or remodeled in Wisconsin Dells. Assessed value of the motels in 1970 was $18 million.

SELFRELIANCE BOARD OF DIRECTORS, 1980S. The Selfreliance Board and Committees included the following people in the 1980s: from left to right (first row) Bohdan Watral, Roxolana Harasymiw, Omelan Pleszkewycz, Roman Mycyk, Roman Bihun, and Alex Poszewanyk; (second row) Paul Oleksiuk, Ivan Leseiko, Ulana Hrynewych, Helen Olek, Oresta Fedyniak, and Ivan Pawlyk; (third row) Michael Pylypczak, Anton Kocepula, Victor Wojtychiw, Orest Koropey, Michael R. Kos, Lubomyr Dzulynsky, and Lubomyr Klymkowych.

THE NEW SELFRELIANCE. This three-story, 23,000-square-foot office building opened in 2002. It includes a large assembly hall for community-initiated events and meetings. In a spirit of cooperation and fraternalism, Selfreliance hosted a welcome party for UNA delegates to the May 2002 convention. Selfreliance also owns a lakefront resort at Round Lake, Illinois, where some 2,000 members participate in an annual Fun Day, sharing in $7,000 in awarded prizes.

BOHDAN WATRAL, CEO. Emigrating to Chicago with his family in 1958, Bohdan Watral earned an accounting degree at the University of Illinois in 1976. He started with Selfreliance in 1978, was appointed treasurer/CEO in 1980, and CEO in 1996. Under his leadership, Selfreliance assets grew from $32 million in 1980 to over $400 million in 2006. Today Selfreliance is the seventh-largest credit union in Illinois.

UKRAINIAN NATIONAL MUSEUM. Located at 2249 West Superior Street, the museum was established in 1952 by Dr. Myroslaw Siemens. Today, museum collectors include regional Ukrainian costumes, agricultural tools, artwork, musical instruments, carvings, ceramics, pysanky (Ukrainian Easter eggs), sculpted wedding breads, and dioramas.

UKRAINIAN NATIONAL MUSEUM PATRONS. Dr. George Hrycelak, pictured here with his wife, Dr. Sophie Welykyj, headed the Ukrainian National Museum Board of Directors for 12 years. It was during his tenure that the museum doubled in size. The museum library holds over 16,000 book titles, and 600 periodicals and magazines. Many Ukrainian art and photography exhibits, as well as presentations by Ukrainian scholars, are sponsored by the museum on a regular basis. The museum is the official home of the Ukrainian Genocide-Famine Foundation, USA. In 2006, the museum hosted, for the third time, an educational program, Ukrainian Saturday School Culture for Homework, sponsored by the Chicago Field Museum of Natural History titled "The Cultural Connection of Chicago."

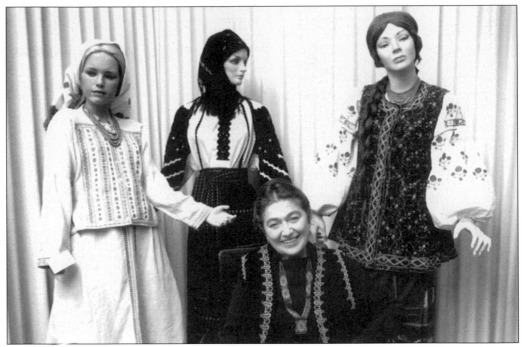

OLHA KALYMON. One of the many volunteers who worked at the museum during its early years was Olha Kalymon, seated here among museum mannequins, who welcomed visitors with her warm personality and sweet smile.

UKRAINE'S FIRST LADY VISITS NATIONAL MUSEUM. Katya Yushchenko (née Chumachenko), wife of Ukraine's President Viktor Yushchenko, visited the Ukrainian National Museum in October 2005. From left to right are Jaroslaw J. Hankewycz, museum president; Katya Yuschenko; and Maria Klimchak, museum administrator.

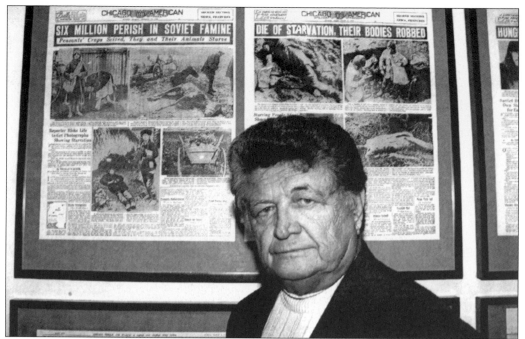

NICHOLAS MISCHENKO. One of the more dramatic displays at the Ukrainian National Museum is devoted to the 1932–1933 Famine-Genocide in Soviet Ukraine. Nicholas Mischenko, seen in this 2006 photograph, is the chair of the Ukrainian Genocide-Famine Foundation, USA, organized in 1983, and formally incorporated in 2003. The foundation distributes a famine-genocide curriculum guide for teachers developed by Dr. Myron B. Kuropas.

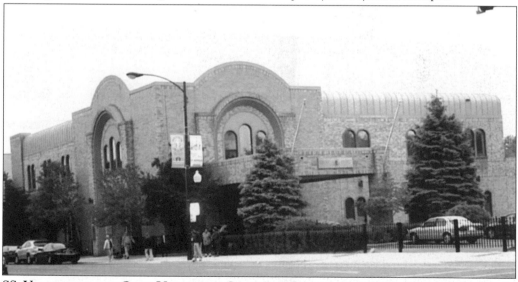

SS. VOLODYMYR AND OLHA UKRAINIAN CULTURAL CENTER. Managed by Oresta Jarymowych, the SS. Volodymyr and Olha Ukrainian Cultural Center is located at 2247 West Chicago Avenue. It is the home of the Encyclopedia of the Ukrainian Diaspora, the Hromovytsia Ballet School, the Ukrainian Catholic Education Foundation, a pre-kindergarten (Sadochok Dzvinochok), the Ukrainian Congress Committee, and the library and archives of the Ukrainian Medical Association.

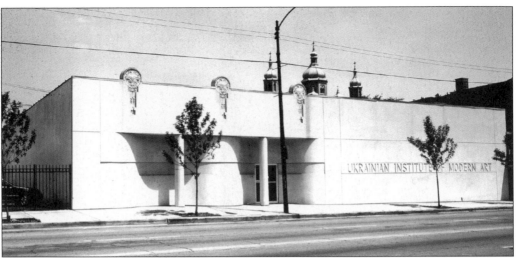

UKRAINIAN INSTITUTE OF MODERN ART. The Ukrainian Institute of Modern Art (UIMA), located at 2320 West Chicago Avenue, was founded in 1971 by Dr. Achilles Chreptowsky. Storefronts were transformed into a museum to serve the local community with cultural exhibitions, literary events, film screenings, music recitals, and lectures. Collections include works by Ukrainian artists such as Jacques Hnizdovsky, Jaroslaw Kobylecky, Alexandra Kochman, Konstantin Milonadis, Oleh Sydor, Alexandra Kowerko, and Mychailjo Urban.

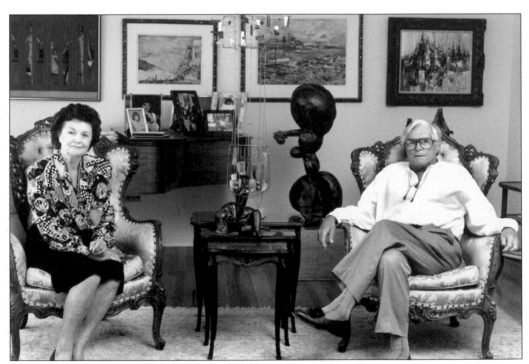

ACHILLES AND VERA CHREPTOWSKY, PATRONS OF ART. Among the most active in the Ukrainian Chicagoland community were Achilles Chreptowsky, a medical doctor, and his wife Vera, shown here in this 1993 photograph. Vera continues her involvement with the UIMA as chairman of the board, while her granddaughter, Laryssa Chreptowsky-Reifel, serves as vice-chair.

OLEH KOWERKO, MUSEUM PRESIDENT. President of the Ukrainian Institute of Modern Art is Oleh Kowerko (left), shown here in this 1995 photograph with, from left to right, his daughter Petrusia, mother Maria, and sister, Orysia Bilas. Lesia Kowerko, Oleh's wife, was out of town when this photograph was taken.

OLYMPIC CHAMPIONS VISIT UKRAINIAN VILLAGE. Ukrainian Olympic gold medal figure skating winners Peter Petrenko and Oksana Baiul visited Ukrainian Village in 1994. Standing between the champions is Rt. Rev. Ivan A. Krotec, pastor of SS. Volodymyr and Olha Ukrainian Catholic Church. To the right of the champions stands the counsel general of Ukraine, Anatolij Olijnyk.

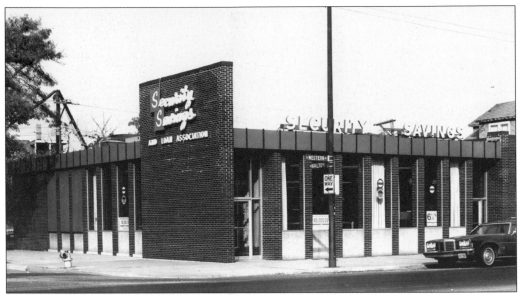

First Security Saving Bank, Pevnist. Purchased in 1964 by Ukrainian investors, First Security Savings Bank (Pevnist) has two major goals: to provide Ukrainians with savings accounts and mortgages for home purchases, and to create a funding source for worthy Ukrainian non-profit institutions. Headed by Julian E. Kulas, assets eventually approached $500 million. First Security was sold to MB Financial bank in 2006.

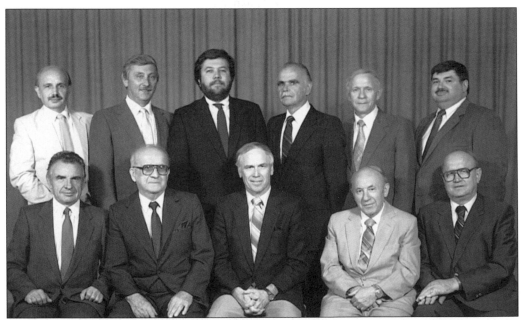

First Security Saving Bank (Pevnist) Board of Directors. In this 1972 photograph, from left to right are (first row) Myron Luszczak, Dr. Roman Kobylecky, Julian E. Kulas, Lev Bodnar, and Yaroslaw Zahorodny; (second row) George Kawka, Myron Dobrowolsky, Taras Gawryk, Vasyl Palahniuk, Stefan Golash, and Lev Keryczynsky. The board of directors established the Pevnist Heritage Foundation with a current base amount of $12 million. The foundation allocates money for worthy Ukrainian causes.

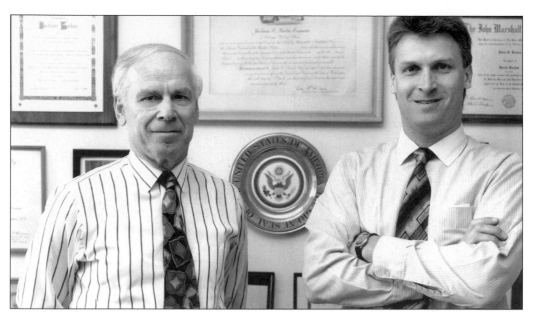

KULAS AND KULAS, ATTORNEYS AT LAW. Born in Ukraine, Julian E. Kulas arrived in the United States with his parents in 1950. An attorney, a banker, a lifelong Democrat, and a Ukrainian activist, Julian was a member of the Chicago Commission on Human Relations, the Holocaust Museum Commission, and the Ukrainian/Jewish Dialogue Group. Julian and his son, Paul J. Kulas, are partners in a law firm in Ukrainian Village.

BORIS ANTONOVYCH, ATTORNEY AT LAW AND HIS WIFE, IRENE. Born in Ukraine, Boris Antonovych received his law degree from the University of Illinois. Practicing law in Ukrainian Village since 1971, Boris represented the 19th District in the Illinois General Assembly from 1976 to 1978. The son of Adam Antonovych, editor of *Ekran*, a Ukrainian-language pictorial journal, Boris and his wife, Irene, seen here on a Dnieper River cruise in 1998, are known for their dedication to Ukrainian causes. Irene edited *Generations: A Documentary of Ukrainians in Chicago.*

ODUM HALL. This building, purchased in 1984 in Ukrainian Village, is the Chicago headquarters of the Organization of Democratic Ukrainian Youth (ODUM). Founded in 1950, most ODUM members are Orthodox Ukrainians committed to the preservation of Ukrainian culture.

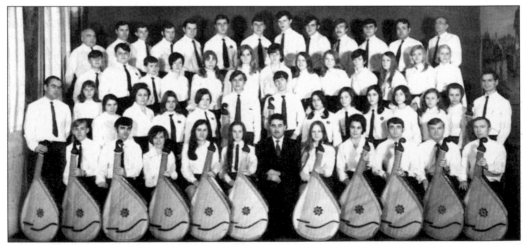

ODUM BANDURA ENSEMBLE. Bandura playing is a specialty of ODUM. The ensemble pictured here was founded by ODUM in 1964. The first director was the legendary bandurist Gregory Kytasty. He was succeeded by A. Luppo, pictured here with the ODUM ensemble in 1970. Bandura playing in Ukraine was forbidden during Soviet times.

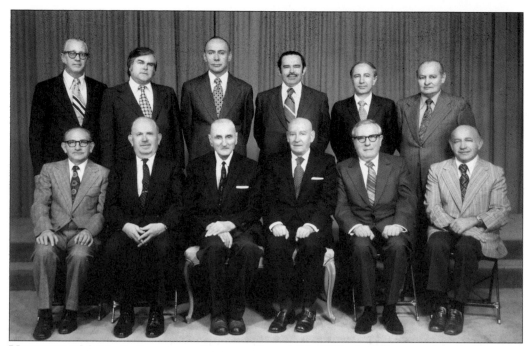

UKRAINIAN MEDICAL SOCIETY OF ILLINOIS. Founded in 1951, the Ukrainian Medical Society of Illinois was headed by these medical doctors, from left to right, (first row) P. Hrycelak, V. Stefurak, P. Ghavansky, T. Worobec, I. Kozij, and P. Mociuk; (second row) I. Daczyszyn, A. Chreptowsky, V. Truchly, I. Cymbalisty, V. Marchuk, and H. Shcherbaniuk.

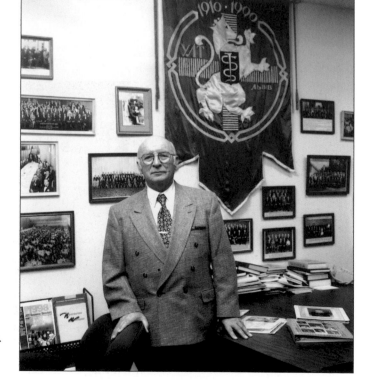

UKRAINIAN MEDICAL ARCHIVES. Dr. Pavlo Pundy was the curator of Ukrainian medical archives located at SS. Volodymyr and Olha Ukrainian Cultural Center for many years. The library and archives contain some 5,000 books and monographs devoted primarily to the history of Ukrainian medicine. The director in 2006 was Dr. George Hrycelak.

SHEVCHENKO SCIENTIFIC SOCIETY (NTS). Founded in Ukraine in 1873, the NTS has branches all over the world. A conference was organized by the Chicago branch in 2004 commemorating the 190th anniversary of the death of Taras Shevchenko, Ukraine's poet laureate, with the following presenters: from left to right, Dr. Pavlo Pundy, Dr. Myron B. Kuropas, Dr. Daria Markus, NTS National President Dr. Laryssa Onyshkevych, Dr. Bohdan Rubchak, Dr. Dmytro Shtogryn, Alex Konowal, George Hrycelak, M.D., and Dr. Vasyl Markus.

STEVE AND ALEX, UKRAINIAN ENTREPRENEURS. Alex Hartler-Sokolohorsky (left) and Steve Borysewycz (right) established Injecto-Mold Inc., a plastics manufacturing plant at 836-40 North Western Avenue in 1964. They pioneered the industrial use of plastics, primarily in plumbing parts, electrical components, lenses, housings, and custom molded products. They purchased a second plant at 2601 North Pulaski Road and reached production requiring some 150 employees. They sold their business in 1990.

SAKS UKRAINIAN VILLAGE RESTAURANT.
Long a landmark in Ukrainian Village, this restaurant at Chicago Avenue and Oakley Boulevard is owned by Roman A. Sacharewycz.

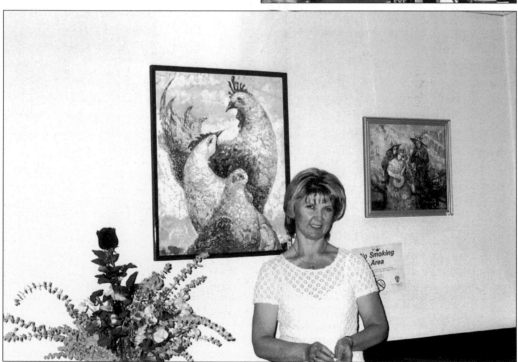

SERVICE AT SAKS. Service at Saks is always given with a smile by Maria Skrupska. The restaurant also serves as an occasional gallery for Ukrainian artists.

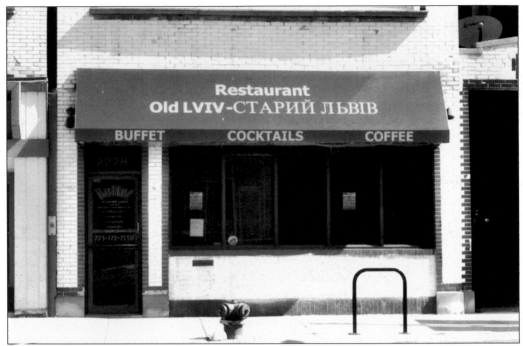

OLD LVIV RESTAURANT. A tasty, inexpensive Ukrainian buffet is offered at Old Lviv Restaurant, located at 2228 West Chicago Avenue, every day except Monday.

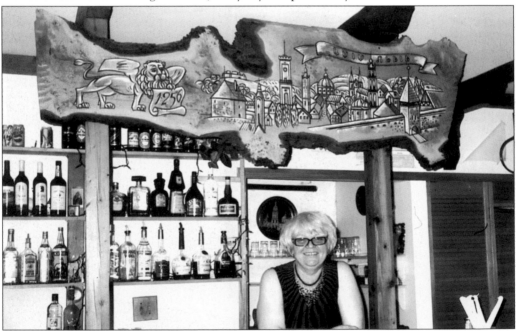

IRENA NAKONECHNA, OWNER/PROPRIETER. Irena Nakonechna arrived from Lviv, Ukraine, in 1990. Four years later, she opened Old Lviv, a Ukrainian restaurant. She went into business upon the urging of her friends. "They liked my cooking," she says. Proud of her success, Nakonechna is living the American dream. "I work long hours, but it's worth it," she says. "My family and I have prospered in Chicago."

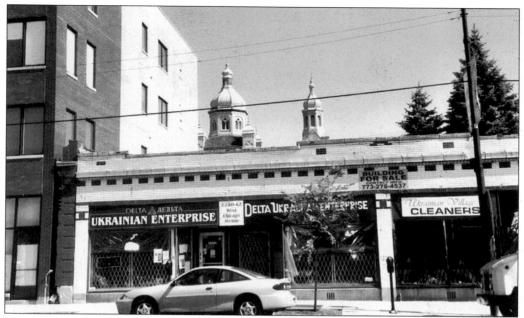

DELTA UKRAINIAN ENTERPRISE. This store, located at 2242 West Chicago Avenue, specializes in offering Ukrainian cultural items including Easter eggs and Easter egg–making kits, ceramics, inlaid woodcraft, embroidery (towels, shirts, table cloths), embroidery threads, china, flags, and books.

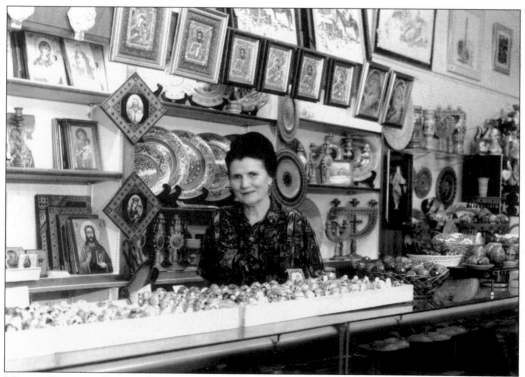

MARIA BRAMA, OWNER/PROPRIETER. Maria Brama stands in front of some of the many Ukrainian cultural items sold at Delta Ukrainian Enterprise, in business since 1983.

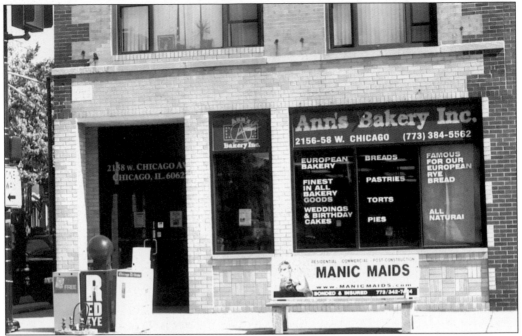

ANN'S BAKERY. Located at 2158 West Chicago Avenue, Ann's Bakery has been a familiar site in Ukrainian Village for decades. A variety of Ukrainian breads, pastries, and other delicacies are made from scratch daily, always fresh, always tasty. Various imported European food products are also available.

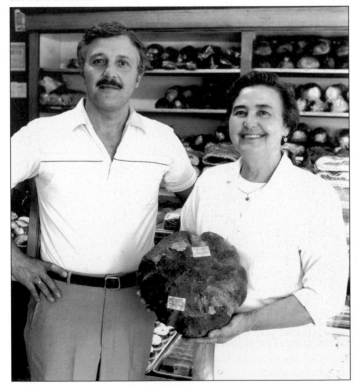

WALTER SIRYJ, OWNER/ PROPRIETER. Walter Siryj purchased Ann's Bakery in 1991 and expanded it to include a small delicatessen and snack bar. It has become a "must" stop for locals, weekend Ukrainian ethnics, and tourists. He is shown here with his sister, Zenovia Devan.

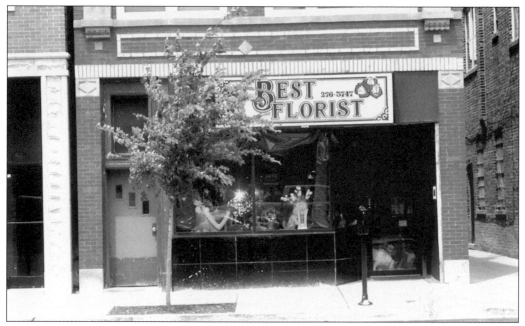

BEST FLORIST. Located at 2224 West Chicago Avenue, this florist shop was opened in 1979 by Valeria Chychula.

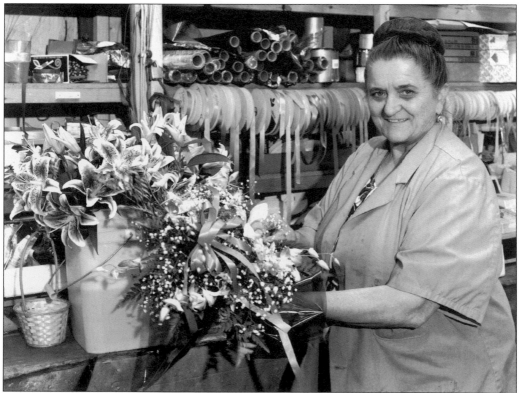

VALERIA CHYCHULA, OWNER/PROPRIETER. Valeria Chychula, who arrived in America in 1951, proudly displays a floral arrangement in her shop.

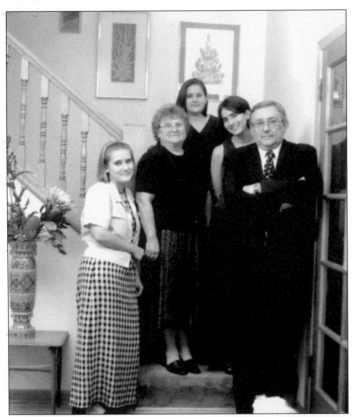

JAROSLAW J. HANKEWYCZ, COMMUNITY ACTIVIST. A certified public accountant with an office located at 941 North Western Avenue, Jaroslaw Hankewycz is one of a growing number of Ukrainian professionals doing business in Ukrainian Village. A community activist, he is the current president of the Ukrainian National Museum. This family picture includes, from left to right, Tamara, wife Maria, Daria, Ksenia, and Jaroslaw.

UKRAINIAN WAVE RADIO PROGRAM. The "Ukrainian Wave" radio program is owned and operated by Mykhailo and Maria Klimchak on WSBC, AM 1240, every Sunday and Wednesday from 7:00 to 8:00 p.m. Founded by Stefan and Lucia Sambirsky in 1950, the program was purchased by the Klimchaks in 1993.

ADAM ANTONVYCH, PUBLISHER/EDUCATOR. Arriving in Chicago in 1949, Adam Antonovych was the editor and publisher of *Ekran*, a monthly photo journal, from 1961 to 1990. He was also director of the Ukrainian Teachers Association Ukrainian Saturday school, director of the Selfreliance children's camp in Round Lake, and president of the Ivan Franko Literary Fund.

UKRAINIAN EVENING TRIBUNE. The Ukrainian Evening Tribune is owned and operated by Lev Bodnar on WSBC, AM 1240 on Thursday evenings, from 8:00 to 9:00 p.m. A loyal member of OUN(B), Bodnar is also active in the Ukrainian National Association and the Ukrainian Congress Committee.

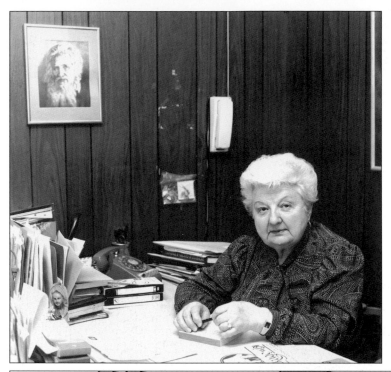

IWANNA GORCHYNSKY, EDITOR. Iwanna Gorchynsky served as assistant editor of the *New Star*, the Catholic eparchial weekly newspaper from 1965 to 1983, and as editor from 1983 to 1998. She is active in the Ukrainian National Womens' League of America (UNWLA), the Ukrainian Congress Committee, and the Ukrainian Encyclopedia of the Diaspora. The current editor of *New Star* is Fr. Oleh Kryvokulsky, pastor of St. Josaphat Ukrainian Catholic Church in Munster, Indiana.

CHAS I PODIYII. One of the first newspapers to be published by fourth wave immigrants in Chicago was *Chas i Podiyii* (Time and Events). The issue shown here was a special edition published especially for the 2002 convention of the Ukrainian National Association in Chicago.

UKRAINIAN TELEPHONE BOOK. The arrival of immigrants from Ukraine after 1990 has resulted in a unprecedented growth of entrepreneurial enterprises. The yellow pages in the telephone book lists dozens of Ukrainian businesses in Ukrainian Chicagoland, many of them owned and operated by recent immigrants from Ukraine. Included is a naturalization study guide for new immigrants with sample questions and answers.

PLAST HOME. Located at 2124 West Chicago Avenue, this building is used by the Plast Scouting and Camping Organization for its multifaceted educational programs, usually scheduled for Saturday afternoons.

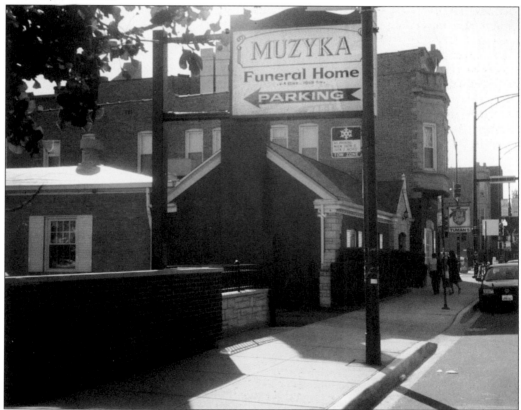

MUZYKA FUNERAL HOME. Founded by Ivan Muzyka in 1915, this is the oldest Ukrainian-run business in Ukrainian Village.

Seven

BRIDGES TO UKRAINE

Prior to the collapse of the Soviet Union, Chicago's Ukrainians were unable to provide assistance to their homeland. There were demonstrations protesting Soviet tyranny, of course, but direct aid was forbidden by Soviet authorities. Even sending packages to families became prohibitive when the Soviets added a tariff that was four times the value of the package itself. Visits to Ukraine were impossible until the Khrushchev era. Even then visitors were closely monitored and often followed by the Soviet secret police. Tourists could not visit relatives in the villages, only in larger towns. Once Ukraine became an independent state in 1991, however, all travel restrictions were lifted. This allowed Ukrainians to visit their relatives in their ancestral villages and to develop programs with Ukraine that would be beneficial to the people who lived there. Chicago Ukrainians have been especially active in building these bridges to Ukraine. A variety of programs were developed, some with the assistance of federal American dollars, others with the help of local donations from Ukrainian institutions, primarily Selfreliance and Pevnist, and various individuals.

UKRAINIAN RESEARCH PROGRAM AT THE UNIVERSITY OF ILLINOIS. The Ukrainian Research Program at the University of Illinois at Urbana-Champaign has sponsored 25 annual academic conferences since its founding in 1981. Professors from Ukraine began arriving in 1989, expanding the academic dialogue between Ukraine and the rest of the world. Shown here are Prof. Dmytro Shtogryn, founder of the program, and wife, Eustachia, his right arm in organizing the conferences.

PARTICIPANTS AT THE 2006 UNIVERSITY OF ILLINOIS CONFERENCE. Standing in front of Illini Union are some of the 102 academics and visitors who attended the 25th annual conference on Ukrainian subjects at the University of Illinois at Urbana-Champaign in June, 2006. Presenters came from Australia, Canada, Italy, Poland, Serbia, Ukraine (32 academics, including 4 rectors), the United Kingdom, and the United States.

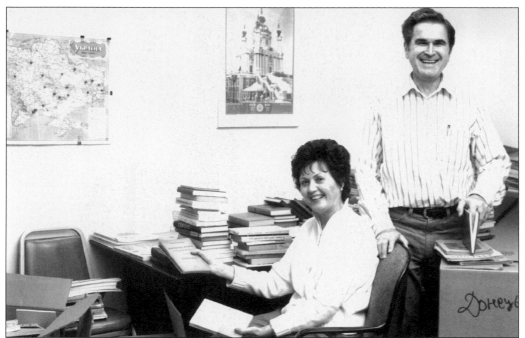

PRESERVING THE UKRAINIAN LANGUAGE. Concerned with the dearth of quality Ukrainian-language literature in post-Soviet Ukraine, Dr. Bohdan and Vira Bodnaruk founded the Ukrainian Language Society of Chicago in 1990. By 2005, they had shipped 818 boxes of books to various libraries and educational institutions in Ukraine. That same year they published *Bridges to Ukraine*, highlighting their efforts on behalf of Ukrainian language preservation.

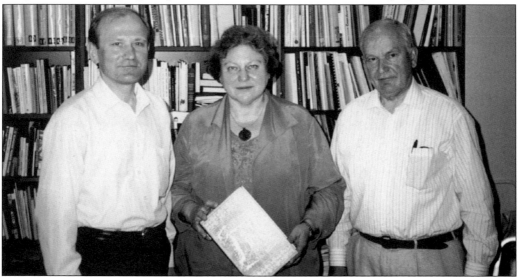

ENCYCLOPEDIA OF THE UKRAINIAN DIASPORA. Vasyl Zhukovsky, vice-rector of the National University of Ostroh Academy in Ukraine, is standing with Vasyl and Daria Markus (holding a copy of her book, *Ukrainians in Chicago and Illinois*). Vasyl and Daria, retired university professors, are compiling an encyclopedia of the Ukrainian diaspora. Volume one (Australia, Asia, Africa) was published in 1995. Volume two, devoted to Ukrainians in the United States, is in preparation.

UKRAINIAN CONSULATE AND CLUB 500. Organized by Dr. Vasyl and Dr. Daria Markus, Club 500, was established in 1992 for the purpose of finding 500 individuals willing to fund a consulate of Ukraine in Chicago. A consulate was opened in the SS. Volodymyr and Olha Ukrainian Cultural Center on October 2, 1992. The present consulate, located at 10 East Huron Street, was opened in 1993.

THE KYIV MOHYLA FOUNDATION. Founded in 2002, the Kyiv Mohyla Foundation is headed by Ihor Wyslotsky of Chicago, shown here with his wife, Marta Farion. Founded in 1615, the Kyiv Mohyla Academy was reestablished soon after Ukraine's second declaration of independence. Known today as the National University of Kyiv Mohyla Academy (NUKMA), the institution offers bachelors and masters programs. Some $1.7 million has been raised by the foundation thus far.

FRIENDS OF OSTROH ACADEMY AND NIU. Founded in Ukraine in 1576, Ostroh Academy was reestablished in 1994. Friends of Ostroh Academy was created by Myron and Lesia Kuropas in 1998. In this photograph, Ostroh rector Ihor Pasichnyk (left) presented a medallion to Dr. Wilma Miranda (center), department chair of Leadership, Educational Psychology, and Foundations at Northern Illinois University. Observing is Natalia Lominska, one of four Ostroh faculty with NIU master degrees in education. By 2006, Friends of Ostroh Academy had raised almost $300,000 for the university.

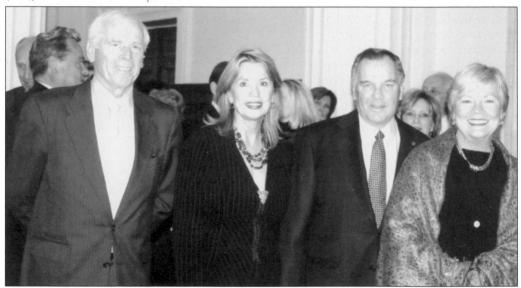

THE SISTER-CITY PROJECT. Chicago became a sister city to Kyiv, Ukraine, in 1991. In this photograph, from left to right, are Julian E. Kulas, Marta Farion, Chicago mayor Richard M. Daley, and Maggie Daley during a visit to Kyiv in 2005. The Chicago-Kyiv Sister Cities Committee is headed by Marta Farion, appointed by Mayor Richard M. Daley in 1995. Committee members include Vera Eliashevsky, Julian E. Kulas, Lida Truchly, and Motria Melnyk.

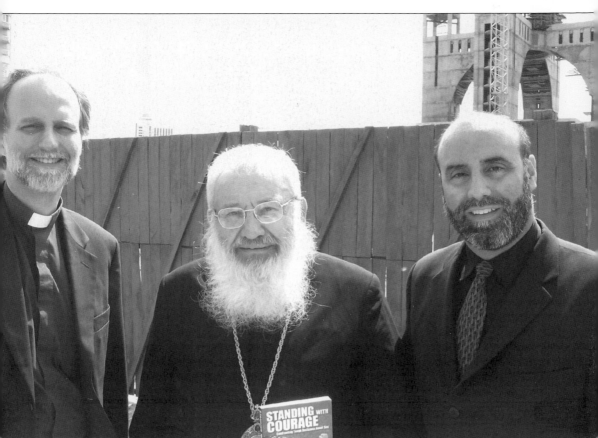

UKRAINIAN CATHOLIC EDUCATION FOUNDATION (UCEF). Ukrainian Catholic University rector Rev. Borys Gudziak (left) stands with His Beatitude Patriarch Lubomyr (center) and Ukrainian Catholic Education Foundation President John F. Kurey Esq., in Ukraine in May, 2005. Housed in the SS. Volodymyr and Olha Cultural Center, UCEF is the fund-raising and information arm of the Ukrainian Catholic University located in Lviv, Ukraine. UCEF provides more than half the funds needed annually by the Ukrainian Catholic University.

CARDINAL GEORGE IN LVIV. Chicago cardinal Francis George visited Ukrainian Catholic University in 2005. With him was Chicago's Ukrainian Catholic bishop Richard Stephen Seminack.

CARDINAL GEORGE IN UNIV. Chicago cardinal Francis George prays over a pilgrim on his way to the Studite Monastery in Univ, Lviv region, Ukraine.

THE ZAJAC PROJECT. Individual Ukrainian Chicagoans have also taken it upon themselves to assist Ukrainians with special needs in Ukraine. Among the most active is Roman Zajac, shown here in this family photograph, second from right. Roman has raised money for wheelchairs and other special equipment for those in need.

THE INAUGURATION OF PRES. VIKTOR YUSCHENKO. The delegation representing Pres. George W. Bush at the 2005 inauguration of Pres. Viktor Yuschenko included three Ukrainian Americans: from left to right, Myron B. Kuropas, a Chicagoland Ukrainian; Vera M. Andryczyk, president of the Ukrainian Federation of America; U.S. Secretary of State Colin Powell; and Nadia McConnell, director of the U.S.-Ukrainian Foundation. The photograph was taken at the American Embassy in Kyiv.

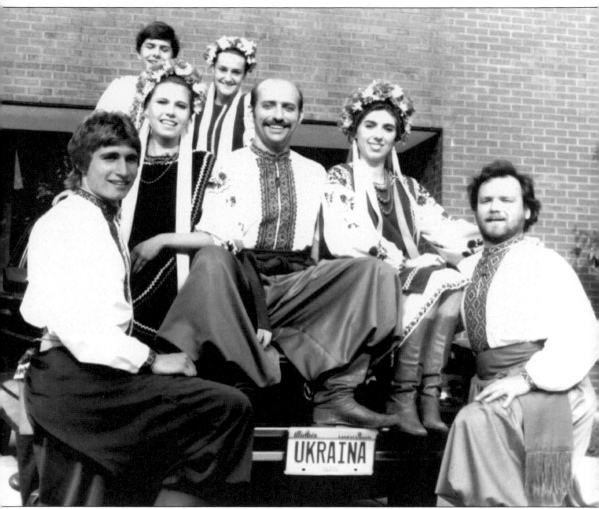

"We Know Who We Are." In contrast to Ukraine's first immigrants to Chicago whose ethno-national identity was weak, these Chicago Ukrainians, members of the SUM dance group Ukraina, know who they are and they are proud of their Ukrainian heritage. From left to right going up are Oleh Kulas, Maria Malook, Mychajlo Banach (in the back), Teresa Kuritza, Iwan Shalewa (legs spread), Oksana Melnyk, and Jaroslaw Trynoha, who owns the car with the unique Illinois license plate. This photograph was taken in 1984.

ACROSS AMERICA, PEOPLE ARE DISCOVERING SOMETHING WONDERFUL. *THEIR HERITAGE.*

Arcadia Publishing is the leading local history publisher in the United States. With more than 3,000 titles in print and hundreds of new titles released every year, Arcadia has extensive specialized experience chronicling the history of communities and celebrating America's hidden stories, bringing to life the people, places, and events from the past. To discover the history of other communities across the nation, please visit:

www.arcadiapublishing.com

Customized search tools allow you to find regional history books about the town where you grew up, the cities where your friends and family live, the town where your parents met, or even that retirement spot you've been dreaming about.